SECRET NORWICH

Elizabeth Walne

D1437946

AMBERLEY

First published 2018

Amberley Publishing
The Hill, Stroud
Gloucestershire, GL5 4EP

www.amberley-books.com

Copyright © Elizabeth Walne, 2018

The right of Elizabeth Walne to be identified as the
Author of this work has been asserted in accordance
with the Copyrights, Designs and Patents Act 1988.

ISBN 978 1 4456 7642 5 (print)
ISBN 978 1 4456 7643 2 (ebook)

British Library Cataloguing in Publication Data.
A catalogue record for this book is available from the
British Library.

Origination by Amberley Publishing.
Printed in Great Britain.

Contents

Introduction

This is *a* Secret Norwich. It is not *the* Secret Norwich. It is, I suppose, *my* Secret Norwich.

The trouble with the idea of 'secret' history or 'lesser-known' history is that the terms are enormously subjective and different readers will have different opinions as to what they feel is well known. I hope that I have pitched the following chapters in the right place.

There is a great deal of popular local history material about murders, ghosts, pubs, yards and more: all very interesting topics and inescapable parts of the interwoven fabric of Norwich's history. These themes inevitably crop up in the succeeding pages, but I have largely avoided them on purpose in order to focus on some of the more obscure history of the city.

I am a qualified genealogist working in a local studies environment and as such have deliberately included stories with a human focus; not just places and dates, but individual thoughts and experiences. My choices for chapters are a compendium informed by the enquiries I have supported – from local and not-so-local visitors – over the past few years. They also reflect my own interests and research, both academic and otherwise. Finally, they incorporate things that I have never yet been asked about – perhaps lesser-known history indeed. I could have written three times as many chapters without having to scrabble around for topics; Norwich is a fascinating place with a colourful and intriguing history.

At the time of the Domesday survey there were 1,358 households in the city. Norwich has since grown to contain more than 70,000 households within the City Council area. Along the way there have been successive waves of immigration including (but not limited to) the Normans, Strangers (many of whom were Dutch speakers fleeing persecution in the Low Countries), Italians, and a temporary influx of American airmen. There have been natural disasters like fires, floods, and plagues, and man-made upheavals from enemy action (particularly the Baedeker bombing raids of the Second World War), as well as planned interventions including slum clearance and redevelopment.

All this adds up to a city in a constant state of change and evolution – for better or for worse depending on your opinion – but a city that nonetheless never stood still. It has been second city of the kingdom, while also at times being seen as a backwater. This contradiction has given our 'fine city' a unique mix of rich surviving heritage and lost features, some of which will be highlighted in the following chapters.

I have endeavoured to provide a few surprises for everybody that picks up this book. Keen Norwich historians will find things that they already know, but I have gone out of my way to find new sources, unpublished images, and archive material to complement this work, and hope therefore that those same readers will find a new anecdote or two. For those who have less existing knowledge before reading, I hope there is much to enjoy.

I meet many people who would like to know more about our city's past. It is clear that new generations are looking for answers and interpretations of that history. These are often generations that couldn't have visited the old Central Library, don't remember the dominance of old city industries like shoemaking and chocolate, and don't have parents or grandparents that lived through the war. Many others, in the grand tradition of Norwich, have been welcomed to the city but have not been here their whole lives.

This book is for all of those enjoying Norwich and its culture and heritage today, in the hope that they and their children and grandchildren are the historians and enquiring minds of the future. I hope this is an entry point to local history that inspires a curiosity, and, with any luck, enough interest to prompt a visit to one of our state-of-the-art libraries and archives to find a few more stories. That way, each and every reader could find and share their very own 'secret Norwich'.

Any errors are my own. It has been a delight to research and write this book, and a great excuse to publish some of my favourite images and tales.

1. Blasphemy and Ball Games

As a new mum, Norwich's parks have reasserted themselves to me as vital components of the city. While planning my chapters, I originally discounted both Chapelfield Gardens and Eaton Park as 'too obvious' for a book called *Secret Norwich*. However, it turns out from discussions with others that the time before their conversion to 'formal' parks (for want of a better term) really is lesser-known city history.

Chapelfield Gardens (although not always known as such) is the earliest surviving example of an ornamental public space in the city. Parks have been – and sometimes still are – edge places, geographically and otherwise. Chapelfield Gardens' story is one of ups and downs, and it begins for us with the founding of a chapel called St Mary's in the Field in 1248, from which it gets its name; Norfolk Record Office has medieval deeds for 'Chapel in the Field' dating from as early as 1313.[1]

Fast forward 300 years from the chapel's inception, and we arrive in a city fresh from the turmoil of Henry VIII's dissolution. The 11,000 people (or thereabouts) who lived in

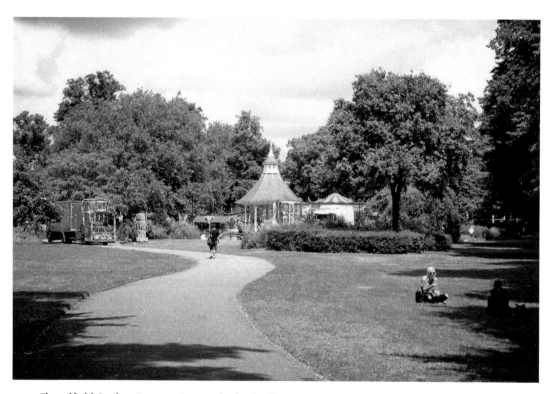

Chapelfield Gardens in 2017 – just as the funfair began to arrive.

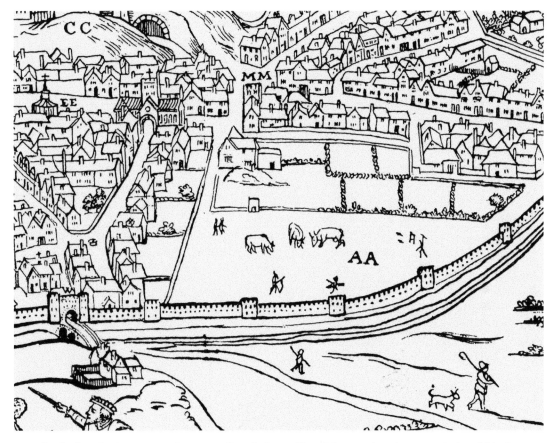

Cuningham's city perspective map of 1558 shows Norwich as a city almost entirely within its fourteenth-century walls, with cows grazing on the field alongside archers practising their aim. (Courtesy of Norfolk Heritage Centre)

Norwich in the early sixteenth century would probably agree with Cuningham's depiction of Chapelfield's land use. A popular and persistent rumour about plague pits, however, is just that – a rumour. It seems more likely that had the city authorities needed to seek burial space outside of the city's many churchyards that it would have been outside the city walls; it seems counterproductive to bury plagued bodies in the centre of a space used as common ground.

Chapelfield's triangular shape, roughly as we know it today, was likely railed off in 1707. Sir Thomas Churchman, apparently on his return from Holland, planted elms, ashes and oaks along perimeter avenues around 1746, shortly after the death of his father, Alderman Thomas Churchman, who built Churchman House (until recently, Norwich Register Office).[2] At this time, we can imagine respectable city dwellers in wigs and/or large skirts perambulating around 'The Chapel Field', and later attending balls or concerts at nearby Chapel Field House (now much changed and part of the story of the Assembly House).

But the Field had been used for recreation for much longer. One Miss Chamberlayne, who attended the Assize Week celebrations in Norwich in 1688, described in a letter how

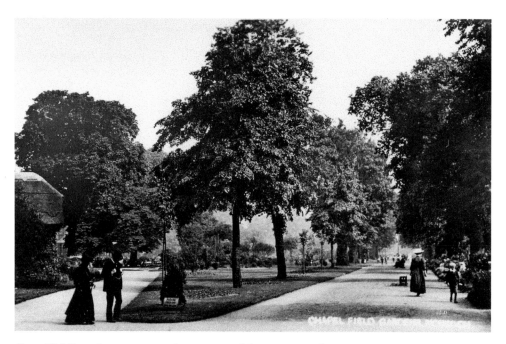

Chapelfield's perimeter avenues have survived for centuries, almost intact. Note the thatched tea pavilion on the left, which was taken down in 1938. (Courtesy of Picture Norfolk)

she heard 'all [th]e nuse..upon the walke' and talks of contemporaries spending 'every night in [th]e garden ... [then] they danced at Chapply feild [*sic*] house ... till 3 in [th]e morn'.[3]

As the eighteenth century progressed, the 'old city' fell out of favour with the well-heeled. The city was becoming ever more crowded and those who could afford it left for larger and more modern homes outside the city walls. By the time the Victorians could reminisce, Chapelfield had a very different feel, and, based on letters to the local press, mid-Victorians thought of former times as the halcyon days of the 'favourite promenade of our beaux and belles'.[4]

In 1783, Chase had included several 'Hints for Public Improvement' in his city directory:

The most eligible situation for a public walk is *Chapel-Field*. Here every thing that taste and judgment could suggest might be done. Trees planted; walks raised and gravelled; seats places at certain distances, and even a piece of water formed in the centre. The inner parallel of the triangle railed, and a good carriage road on the outer.

Chase also suggested public 'bath rooms' to front Chapelfield, and resolving the city's then existing water quality issues by raising the height of New Mills instead of installing a talked-about reservoir in the centre of Chapelfield. However, nine years later, the Water Works Company built just that, along with a red-brick water tower for good measure. For several decades it was possible to skate there in winter, although for James Nudds and Charles Styles it would be the last thing they ever did – inquest records show that they fell through the ice and drowned in 1808 and 1813 respectively.[5]

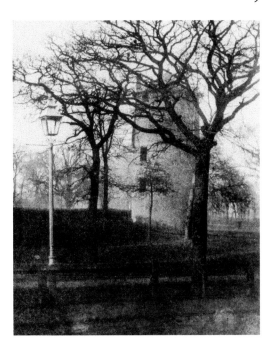

Chapel Field water tower, *c.* 1840 – recently digitised from a lantern slide. (Courtesy of Picture Norfolk)

The reservoir did nothing to restore propriety and by the 1840s there was growing disquiet among the more genteel about the condition and use of Chapelfield, which had become the haunt of the city's least respectable. This is a somewhat forgotten history of a well-loved city space, and perhaps for good reason. Mr Barker wrote to a local paper to state there were 'scandalous and discreditable scenes ... the town wall will be pulled down ... the grass and young trees entirely destroyed, the fine chestnut trees ... mutilated and their beauty defaced by large stones ... thrown by a few lawless and desperate scoundrels ... which they accompany with threats and language of the most foul and abhorrent nature.'[6]

Mr Dixon, concluding a report in 1845, went even further: 'Chapel Field has a filthy ditch always replete with dead dogs, cats, ordure and stagnant water.' He continues,

> I beg ... to call attention ... to a part of the city which might be made a gem of Norwich ... For a small expense the foul ditch might be filled up; the fence, beyond which the eye cannot penetrate to the water, be replaced by a beautiful slope and handsome palisade; a small policeman's house, at each corner of the field, for steady men, whose sole duty should be to admit every person who behaved properly; but to expel the riotous stone-throwing urchins and blasphemous prostitutes, and men who now infest it by day and night.

The report tells us that the only places the city's poor children were allowed to play were Castle Meadow and Chapel Field. Dixon's report on the state of Norwich is somewhat damning: a city in a 'painful state of transition from a once flourishing manufacturing prosperity to its entire decline', where the streets are unhealthy and overcrowding 'leads to fever and immorality'.[7]

Over the next couple of decades potential improvements were mooted, but not all were realised – for example, a statue of Nelson in the centre of the reservoir and a somewhat Rapunzel-esque overhaul of the water tower. In the end, the reservoir was filled in during 1854 because it was no longer needed. The water tower was demolished too, but still no public gardens were created.

A letter to the *Norfolk Chronicle* in 1865 again deplored the 'disgraceful Chapel Field'. The author believed Norwich should be ashamed of the space, which, despite still being 'studded with magnificent trees' was nevertheless 'exposed to every species of wanton injury, and instead of being the favourite resort and promenade of our fellow citizens, is chiefly the rendezvous of the lowest grade of our population, and too notoriously prolific after dark in immorality and vice'. The writer was just one more voice hoping for a restoration of the good times, so that Chapelfield 'would cease to be an abomination and become an ornament to the city'.[8] It would take another fifteen years for the gardens to be completed.

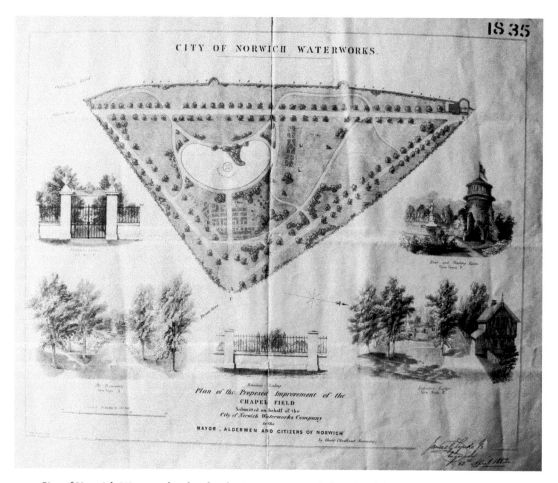

City of Norwich Waterworks plan for the improvement of Chapel Field, dated both 1835 and 1852. (Courtesy of Norfolk Heritage Centre)

Meanwhile, Chapelfield was enclosed, and the Drill Hall was built, initially for the 1st Norfolk Rifle Volunteer Corps. Digging commenced in April 1866, and, thanks to the Prince of Wales having 'condescendingly signified his willingness' to open the hall, it was hastily (almost) completed in order that an official opening could take place on 30 October that same year. The local press reported:

> [The Drill Hall] occupies the site of a portion of the old city wall, and of a number of old buildings and workshops which had in the course of many years clustered at the outer base of the city wall, and which completely spoiled the effect of a main thoroughfare to and from the railway station.[9]

The paper adds that men who had previously consented to the removal of another large piece of wall for 'respectable shops' were suddenly 'seized with a feeling of deep reverence for the old wall', which made up part of the new building. Could this be evidence of shifting attitudes, or just romanticism? Instead of demolishing the 'old fashioned' gates for progress, some of those in authority might just have been moving towards today's prevailing attitude of celebrating surviving parts of the city's medieval heritage.

However, the city's days of demolishing walls were certainly not over. The Drill Hall and the old tower within it were demolished in 1963 after nearly 100 years of military activity and other events in order to make way for the ring road. Consequently, Churchman's avenues no longer come to a sharp point at the corner nearest Pedro's restaurant. The lost wall is hinted at with a line of bricks within the modern-day roundabout, but otherwise there is little suggestion of the building or wall that once stood on the site.

Ladies in fabulous hats outside the Drill Hall, from a lantern slide dated *c.* 1910. (Courtesy of Picture Norfolk)

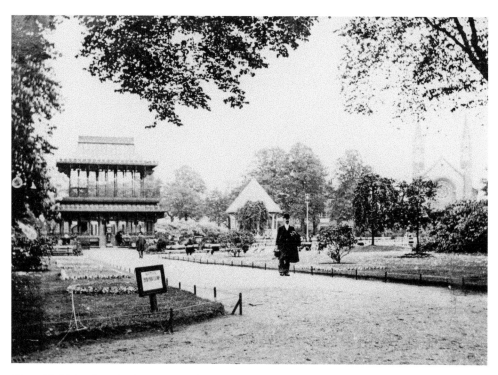

Chapelfield Gardens laid out as a public park, showing the pagoda and, on the right, the now demolished Chapel Field East Congregational Church. (Courtesy of Picture Norfolk)

Despite more recent developments, the public gardens (finally opened in November 1880) would have been fairly recognisable today. However, the pavilion (or pagoda, if you prefer) was rather more striking than the current brick café. Chapelfield has been the scene of fêtes, festivals, celebrations, picnics and a myriad of other events ever since – and long may that continue.

When Chapelfield Gardens opened, Eaton Park was still farmland. Today, it is one of Norwich's four Grade II-listed parks – the others being Heigham, Wensum and Waterloo Parks. Mile Cross Gardens, Earlham Cemetery, and the Plantation Garden are among other city spaces that can also claim Grade II listing. The layout of Eaton Park we know today was principally designed by Captain Sandys-Winsch, and officially opened in 1928.

Eaton Park is perhaps the best known of the four listed parks, but like Chapelfield its earlier history and creation is less well known than its post-1928 incarnation. Also like Chapelfield, Eaton Park was once on the edge of the city; the Farmhouse Pub on Colman Road really was at one time part of a farmyard surrounded by fields. It was called Eaton North Farm in the 1880s, and later North Farm Tea House as different business opportunities arose. The character of the surroundings changed relatively little until the 1920s, when large areas were newly developed for residential areas on the south-west (and indeed other compass points of the city) during an interwar building boom.

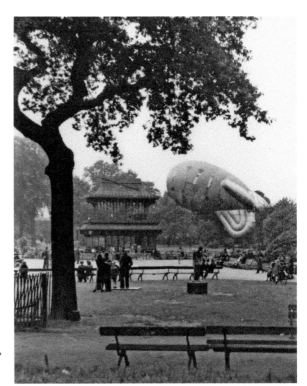

Right: Barrage balloon in front of Chapelfield Pagoda in 1944. War damage meant the loss of this landmark. (Courtesy of 2AD Memorial Library)

Below: Parts of the ironwork from the pagoda survived and have been reinstalled, along with newer interpretations, within the entry gates of the modern-day park.

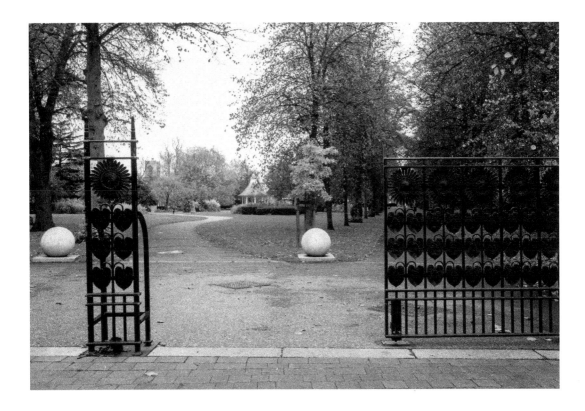

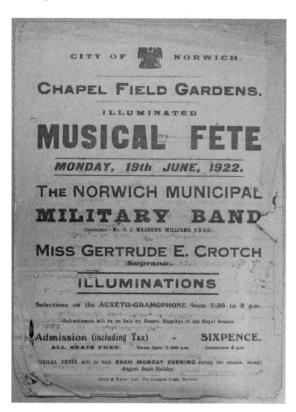

Left: This event flyer has survived because several similar pieces of paper were used as scrap paper for note taking – an example of accidental preservation! (MC 1434/1, Courtesy of Norfolk Record Office)

Below: Eaton Park.

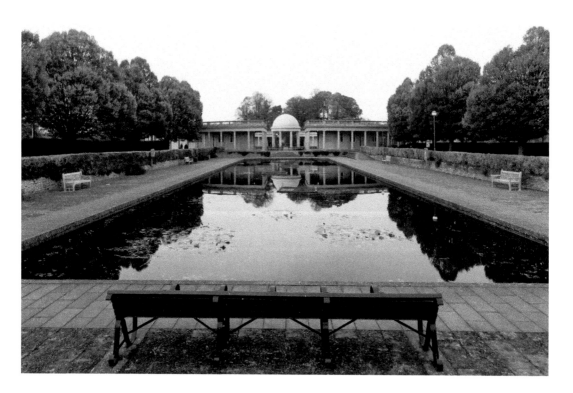

While the construction of the Colman Road estate linked the ground that would become Eaton Park to the city in 1924, the planning for a leisure area had begun somewhat earlier. Recommendations for acquisition of 'certain land situate in the Hamlet of Eaton for recreative purposes' to a council of the City of Norwich Corporation (a forerunner of the City Council, made up of councillors and aldermen) as early as 1905.[10] A total of 78.5 acres were then available from the Ecclesiastical Commissioners, including areas known as 'Eaton Hangs' and 'Bluebell Hole' for £4,900. We must thank the forward-thinking Playing Fields and Open Spaces Society for contributing £900 towards that total.

The assembled council was recommended to approve and support the purchase because it was offered at a reasonable price, and because missing the opportunity may cause future citizens to believe a great mistake had been made. The ground would lay the foundation for a healthy and prosperous generation, and go some way to prevent the 'deterioration evident in the national physique'. The statement went on, 'With Mousehold at one end [of the city], and Eaton ground at the other, the citizens could not help being proud'. It was not intended that Eaton be a formal park at this time, but rather 'a large recreation ground, where football, cricket and other games could be dealt with in reason'.

Harking back to the purchase of Chapelfield Gardens, the city's Mr Wild said that there had been widespread criticism then of attempting even the smallest garden, but those complaints were proven to be completely unjustifiable. He was able to report that after two days' holiday in fine weather, not a single case of drunkenness had come before the bench, but there were, on the other hand, several boys in trouble for playing football in the street!

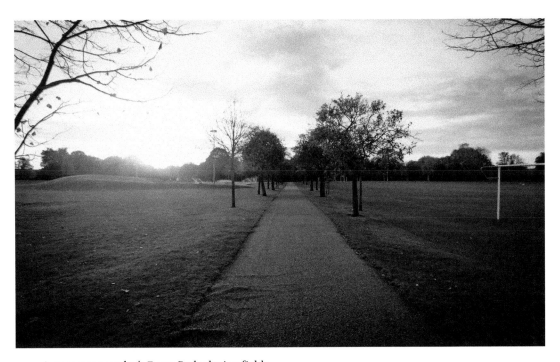

A sunset over today's Eaton Park playing fields.

It was not a given that the land would be purchased. Several men in attendance at the meeting commented on the financial burden the council would be undertaking: Mr Scarles said that there was a mania for spending money that could not be afforded, while Mr Curl added that the park was not wanted. Mr George White countered that the ground *was* wanted today – because so much open land had disappeared over the last few years.

Despite the political wrangling, the land for 'fresh city lungs' was purchased and used for more than twenty years for a combination of games, the Royal Norfolk Agricultural Show, and even for training soldiers for the trenches, among other things. Until the 1930s it was possible to travel to Eaton Park by tram, walking from the Unthank terminus opposite the Jenny Lind Hospital (which closed in 1975; the Colman Hospital now occupies the site). The local newspapers report many sports events and matches being held at Eaton Park Ground from its earliest existence. Teams included the Norwich Insurance Clerks, the Police, the Norwich Grasshoppers, the Scarlet Runners, and the Argonauts, some of whom travelled from other towns to play city teams. The ground also played host to school sports days and Empire Day.

During the war years, thousands of men trained at Eaton Park. The YMCA reportedly put temperance canteens up to try to bring the units together without alcohol.[11] The City Volunteers (1st City of Norwich Battalion) was inspected at Eaton Park in late September 1915, apparently in front of several thousand citizens. The battalion was made up of 'many ex-servicemen and old volunteers ... campaigns represented going as far back as the first Egyptian War'.[12] By 1917, parts of Eaton Park were earmarked for cultivation as part of the war effort, and there were also calls to plant vegetables in the flower beds of Chapelfield. According to the town clerk, 10 tons of potatoes had been ordered.[13]

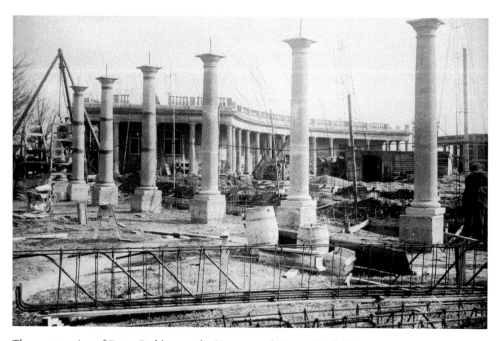

The construction of Eaton Park's rotunda. (Courtesy of Picture Norfolk)

Two years later, an unusual spectacle came to Eaton Ground: the dropping of London's Sunday newspapers by parachute from a Handley-Page aeroplane flown directly from the capital. The aeroplane continued on to Cromer and Great Yarmouth, where, unfortunately, the last bale was dropped into the sea and had to be rescued by a boat and brought back to Britannia Pier.[14]

In 1924, changes came. Plans were signed off and nearly three years of development began, giving us the Eaton Park we know and love today. Labour was supplied by men who had returned from war and survived the influenza epidemic that followed only to find no employment. In 1921 the city had 7,000 unemployed, not including those on 'short time'. Large projects were needed to provide work for a sizeable number. One hundred and three men needing labour were employed each week. The new park was later officially opened by the Prince of Wales.

Arthur Smith, taking part in the recent Norfolk HistoryPin Connections project remembers:

I did go to the opening of Eaton Park. There were two hundred of us kids invited. They sent choristers and we led the singing. It took place around the bandstand. There was a lily pond and a boating pond. And they used to sail beautiful boats on there. In the early days there was an enormous amount of space.[15]

During his time in office Captain Arnold Edward Sandys-Winsch, the park superintendent for Norwich Corporation, grew the city's open spaces portfolio from Chapelfield Gardens, the Gildencroft, and Sewell Park, to approximately 600 acres of recreation space. His role was a new one when he began his work, the City Engineer's Department having

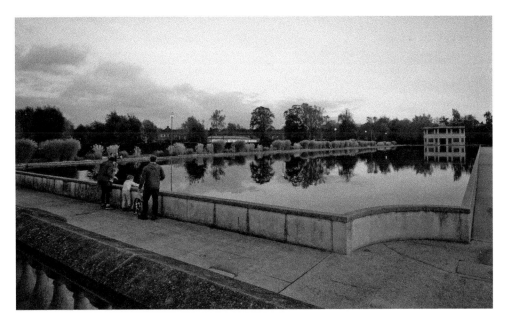

Eaton Park's boating lake at dusk.

previously been responsible for the city gardens. Captain Sandys-Winsch was in the post for thirty-three years. A bench dedicated to him, and another to the local men who built it, can be found beside the boating lake, where today my little boy is able to sail his boat in the same way that his great-grandfather did.

DID YOU KNOW?

A copy of William Cuningham's original volume, in which his perspective was included, *The Cosmographical Glasse (Conteining the Pleasant Principles of Cosmographie, Geographie, Hydrographie or Navigation)*, can be found at Norfolk Heritage Centre inside Norfolk and Norwich Millennium Library. Cuningham's map is currently believed to be the earliest surviving printed map of an English town or city.

DID YOU KNOW?

In the 4 June 1910 edition of the *Norfolk News* it was reported that on 2 June Eaton Park played host to Yeomanry Sports – a 'very agreeable affair'. Spectators watched feats of riding skill, gymnastic displays with swords, wrestling, and an exciting competition of combination tent pegging, all while the competitors were dressed in their bright uniforms.

DID YOU KNOW?

The *Diss Express*, on 26 June 1914, reported on the Royal Norfolk Show of June 1914 at Eaton Park. It hosted 495 horses, 149 cattle, 171 sheep, 103 pigs and 143 stands – record numbers. That year incorporated the Rose Show as well as the first appearance of the poultry section. Visitors were entertained by revolver shooting, beekeeping lectures, butter-making competitions, and a 'particularly fine' selection of shire horses and Red Poll cattle.

2. Trial and Transportation

Historically, men have made up the greater proportion of convicted criminals and imprisoned debtors. Men also outnumbered women transported to the colonies by as many as six to one. For this reason, many of the most well-known Norwich trials involve males, while the few well-known cases involving females are for headline-grabbing crimes like murder. But what about everybody else? Women could and did end up in the penal system in Norwich and many were imprisoned or even executed, often for crimes we would consider petty today. This chapter looks at some of the women who, between 1600 and 1900, were involved in one way or another with Norwich courts and their subsequent fates.

Working chronologically, we first meet Jane Sellars, who was frequently shuttled before the mayor's court in the 1620s and 1630s.[16] At the time the use of the bridewell – a place originally for the poor to work, with women being put to spinning and carding – was booming in Norwich. Jane was whipped at the post many times over eight years as well as being imprisoned at least ten times. Most of her appearances were at the mayor's court for 'living idly', being a vagrant, begging, running away from her master, lewdness or ill rule. However, it was the felony of theft that led to her branding, and finally, in 1631, to the sentence of death by hanging. The last sentence was called after she reputedly entered a house and stole goods to the value of less than twelve shillings.

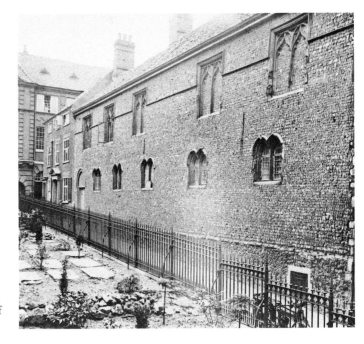

Now the Museum of Norwich, the Bridewell was intended as a place for the (often young) city ne'er-do-wells to do some honest work. (Courtesy of Picture Norfolk)

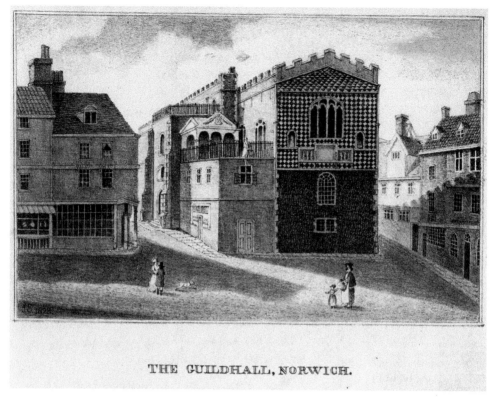

THE GUILDHALL, NORWICH.

The Guildhall – home of the mayor's court and quarter sessions for the city of Norwich at the time of Jane's trials. (Courtesy of Picture Norfolk)

Jane was also a mother. Court records note that her child was sent to the wife of Matthew Grove in St Swithin's in May 1630, days after a theft that brought her face to face with the quarter sessions authorities for the first time. On 4 August 1630, her child was delivered back to her. Over the following months she appeared in front of magistrates several times, her branding taking place after another appearance at the quarter sessions on 8 August 1631. This much can be gleaned from court records, but I believe I can add to the story. Just four days after this last sessions appearance, her son appears to have been buried. Gaskyne (potentially named for his father, to whom Jane was not married, or a family surname – conjecture, but not uncommon) appears in St Benedict's burial register. There were other Gascoignes (and spelling variants) in the city, and one gentleman with that surname even appears in the same court records as Jane.

The Myles family of St Benedict's also suffered that month, burying several family members before the day of Gaskyne's burial, which coincided with the burial of another Myles child and their servant Debera. We know that plague stalked the streets of Norwich that summer but we can't know for certain that is was the cause of Gaskyne's death. He was born into poverty and moved back and forth between Jane and foster parents named by the court at a time when even those belonging to the richest families had a significant probability of dying before the age of one. Poverty, crime and disease walked hand in hand.

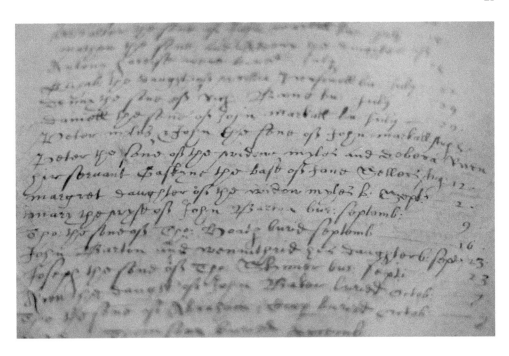

Above: Middle line (in focus) reads
'...Gaskyne the base of Jane Sellers
Aug 12...'. (PD 191/1, Courtesy of Norfolk
Record Office)

Right: St Benedict's Church was
damaged during the Baedeker raids of
the Second World War. Today, only the
tower remains, surrounded by blocks
of flats.

As for what became of Jane herself, it is not entirely clear. She does seem to be missing from further court and parish records after 1631, although absence of evidence doesn't categorically prove evidence of her absence. If she was hanged at Castle Hill or Ditches as per her sentence, then it is tempting to think she was buried at St Michael at Thorn – known to have been the resting place of many executed felons. Because the original parish registers for the church were destroyed in the Baedeker raids of 1942 it is not possible to check for an entry. Normally, contemporary transcripts might be an alternative, but those for 1631–32 have not survived either, so there is no documentary evidence (at least that the author has discovered so far) to prove it. Local historian Frank Meeres believes she may have been the last person hanged by Norwich's quarter sessions – later on, capital offences were dealt with at the assizes. Of course, we already know that 1631 was a plague year on top of the usual risks of life at the lower end of society in Stuart Norwich, so perhaps she succumbed to disease while awaiting her sentence instead – we may never know.

Many others certainly did die while imprisoned, whether criminals or debtors. As many as 30 to 40 per cent of deaths between 1669 and the mid-1700s recorded in Verdicts of Inquest Juries' records at Norfolk Record Office occurred at the City of Norwich Common Gaol, which at that time was on the site of today's Library Restaurant.[17]

Some example inquests include:

- In 1727 Elizabeth Tenant, aged eighty-six 'or thereabouts' who was 'afflicted by the immediate hand of God with a fever and mortification in her leg of which she languished till ... she expired'.
- In 1742 Ann Goose, 'a felon convict under sentence of transportation of the age of 28 years or thereabouts being afflicted ... with the Small Pox about a fortnight since languished'.
- In 1749 Elizabeth Bayes, aged nineteen, 'who was taken with a distemper called the Small Pox'.

St Michael at Thorn has now been lost but for a few fittings that moved elsewhere. Also damaged during the Baedeker raids, the site now lies under Archant's car park. (Courtesy of Picture Norfolk)

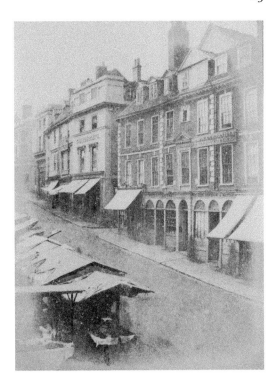

An early image of Gaol (or Guildhall) Hill from the Eaton Collection. (Courtesy of Picture Norfolk)

The inquest of Ann Goose.
(NCR Case 6a/7/30, Courtesy of Norfolk Record Office)

Two centuries after Jane was or wasn't hanged, other Norwich women were instead transported to Australia. Sophia Riches and Caroline Tuck are just two examples from the city of Norwich.

Sophia Elizabeth Riches was probably born in the parish of St Peter Mancroft in January 1831 and baptised at the parish church on 9 February 1831. She was the daughter of Charles (a glover or tanner depending on the record; working with leather either way) and Elizabeth. By 1841, Sophia was living with her parents and a younger sister, Elizabeth, in Shuttle Yard, Heigham, close to the Shuttles beerhouse. Her age is not always consistent through the documentary record, but research has given a suitable confidence level for her story to be included here.

Not so far away, another baby girl was born on the day of Sophia's baptism. Caroline Tuck was from the parish of St James with Pockthorpe and baptised at the parish church on 13 March (the church is now the Puppet Theatre). Caroline was the daughter of William and Margaret of St James, and her father made a living as a whitesmith (like a blacksmith, but using lighter, softer, metals like tin). St James is remembered as one of the poorest areas of the city. Caroline had at least two older brothers, Thomas and William, and by 1841 was living at St James' Palace, which sounds a lot more upmarket than it was: at that time the area was really a slum next to the workhouse.

Sophia seems to have got into trouble with the authorities first. She appeared before the city sessions at the Guildhall on 6 January 1846 for larceny. The newspaper fills in that she had stolen a pair of boots belonging to Thomas Sacret of St Clements. The article adds that she could not read and write, and was sentenced to two calendar months' imprisonment.[18]

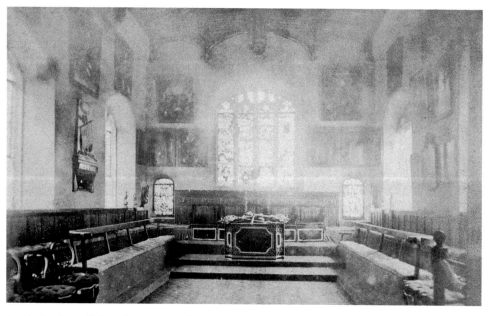

Inside the Council Chamber at Norwich Guildhall. Quarter session trials would normally take place in the neighbouring Assembly Room. (Courtesy of Picture Norfolk)

Caroline was in trouble too only a few months later. Working with one Mary Ann Edwards (three years her senior if their ages are to be believed) the pair were indicted for stealing a single silk handkerchief. Both pleaded not guilty at the city sessions on 19 October 1846. We learn from the criminal register that Caroline had no 'degree of instruction' and that she received fourteen days' imprisonment. The newspaper reported that the girls had entered the shop of Mrs King on the pretence of buying a dress, and on their leaving, Mrs King noticed the handkerchief missing.

A little detective work revealed that the handkerchief had found its way to a pawnbroker's, where it had been pledged by the prisoner (likely Mary Ann). It was recognised that Mary Ann had been in trouble before and had taken the principal role. She was sentenced to seven years' transportation and was already in Van Diemen's Land (now Tasmania) by 21 July 1847, six months later. Caroline, as a first offence, was given fourteen days with solitary confinement, most likely at the city gaol, by now moved to St Giles, where the Roman Catholic cathedral now stands.[19]

Only a few months later, Caroline was back at the Guildhall, this time committed for trial after stealing *several* handkerchiefs from one Mr Snowdon of Bridge Street. One wonders whether she had been a serial thief for a while or whether she had learnt the knack (perhaps not very well) from Mary Ann.[20] It has been said that silk handkerchiefs were a thief's starting point: small, but with a relatively high resale value, they were easy to pass on.

It was at the proceeding sessions that the two women featured here would appear one after the other. We cannot know how well – or even if – the two knew each other, and if so how much contact they had, but both came before the bench on 29 June 1847.

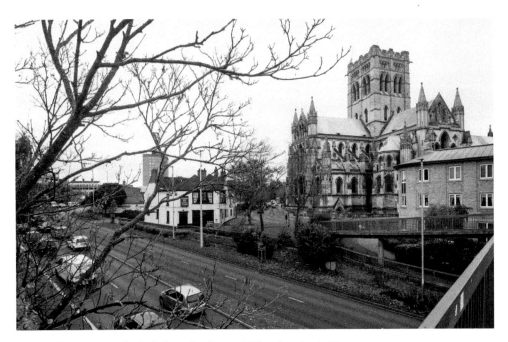

St John the Baptist Cathedral, from the Grapes Hill pedestrian bridge.

Sophia was charged with stealing a brass weight and two other pieces of brass from Matthew Blyth of St Martin at Palace. The jury found her guilty and, as it was not her first offence, she received seven years' transportation. Caroline, pleading guilty for stealing three silk hankies, again after a former conviction, received the same verdict and punishment.[21]

The girls were sent back to the city gaol, at that time a building two decades old. The gaol had an infirmary, two debtors' wings, iron doors, three treadwheels and a place of execution. There were sixty-nine sleeping cells and a schoolroom. Only a couple of years before our ladies were in residence, in 1843, there were 859 prisoners, of whom 129 were debtors.[22]

After three months more in Norwich, the pair were removed to Millbank Prison, from whence they would walk down the Thames steps onto a ship called the *Elizabeth and Henry*, and embark on their voyage around the world. It would be the ship's third and final convict voyage, and it lasted from 11 February to 30 June 1848. All 170 convicts on board were women. Inaccurately, some have termed these ships 'floating brothels'. Really, the vast majority were convicted of theft, like Sophia and Caroline. They were the only Norfolk women aboard.

On arrival in Van Diemen's Land, Caroline and Sophia were put to gang probation. It meant six months at Anson Probation Station – an ex-convict ship moored in Prince of Wales Bay. As both were 'third-class' criminals, they were separated from the 'worst' of the

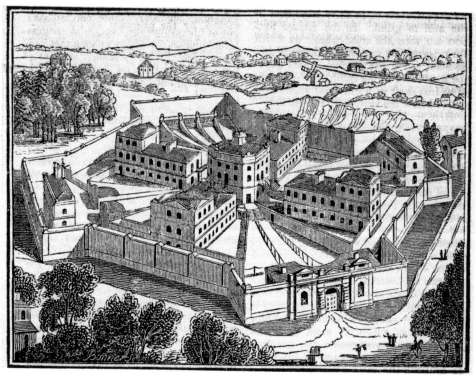

The New Prison as seen in 1827 from St Giles Church tower. (Courtesy of Picture Norfolk)

female convicts. The system was meant to be progressive, starting with confinement and labour in gangs (probation stations for most, penal settlements for those transported for life). Gradually, the severity was reduced until the transportees were given probation and were made available for hire by settlers. Eventually, prisoners received a ticket of leave and pardon before freedom.

The future for both women was their new country. Both were to marry at St George's Battery Point (built by other convicts), which still graces the Hobart skyline today, within a year or two of arrival. This was hardly surprising as women made up as little as 4 per cent of the convict population at that time and marriage was encouraged in the hope that subsequent children would grow the penal settlement into a viable colony, as well as offering the women a chance at rehabilitation.

Caroline married a shoemaker called John Smith and, consequently, becomes rather harder to trace. However, recently digitised records suggest the couple moved to Victoria where they had at least eight children, settling in Steiglitz, Victoria, after a brief spell in Ballarat – both gold rush towns in the early 1850s. By 2015 Steiglitz had shrunk to a population of just eight people. Sophia Riches married a groom (for horses) and lived to be seventy-one according to her death certificate. At the time of her decease she was still living in Kingston, just south of Battery Point, as Henry Riches' widow, and the register states that he was a farmer. Further records suggest that Sophia had at least nine children and has a very large number of descendants.[23]

For both women, Australia was a new beginning – whether they wanted it or not. A chance of a new life, however well they felt it turned out, was more than city women like Jane Sellars and Ann Goose had had in the centuries before.

St George, Battery Point, Hobart.

Left: Believed to be Sophia Riches in later life.

Right: Local lore says that criminals would be tied here – at the rear of the Guildhall – to receive their punishment, e.g. whipping or branding. Evidence for this is rather harder to come by. (Copyright untraced)

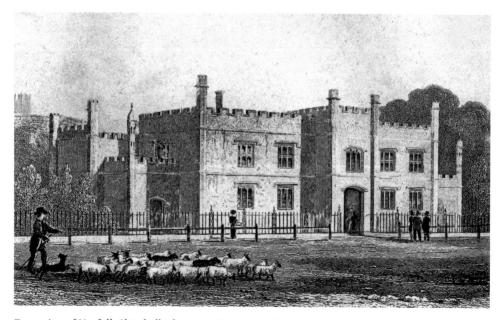

Engraving of Norfolk Shirehall when new. (Courtesy of Picture Norfolk)

DID YOU KNOW?

Rather confusingly for a modern reader, the handkerchief stolen by Mary Ann and Caroline, although from Mrs King's shop, is identified as the property of Mr King in court. This is because the trial dates from before the Women's Property Acts of the 1870s and 1880s; the handkerchief, like everything else that Mrs King might have owned before her marriage or earned through her own work and industry, was legally the property of her husband William. Therefore, it is he who appears as the prosecutor in the trial.

DID YOU KNOW?

St Michael-at-Thorn Church – which apparently referred to the thorn trees that had long graced the churchyard – was damaged by incendiary bombing in 1942 and demolished ten years later. Unlike St Benedict and St Bartholomew (Heigham), the tower was taken down too. The doorway can be found at the rebuilt St Julian. Therefore, St Michael-at-Thorn disappeared like St Paul on Barrack Street. Today, the former site is under Archant's car park and the latter is marked by the old perimeter trees, which now border a playground at the bottom of the ring road flyover.

DID YOU KNOW?

Norwich is also home to the Shirehall, where another courtroom has been restored. It can be confusing at first for researchers to distinguish between the county of Norfolk criminal processes (with a prison at the castle and a tunnel leading directly to the courtroom at the Shirehall) and the county of the city of Norwich processes (with a prison on Gaol Hill and later St Giles, and courtrooms at the Guildhall). The most serious crimes from both county and city would be tried by the visiting assize court but that too would usually try Norwich cases at the Guildhall and Norfolk cases at the Shirehall.

3. Beneath Us and Beside Us

Many of Norwich's former residents are under our feet. Whether we know it or not we shop, work, play and reside above their remains, quite apart from going to gigs, visiting art exhibitions, drinking tea, or learning circus skills in redundant churches above ancestors buried in vaults. Each day, researchers come to my place of work to locate the final location of their forebears or the city's great and good – or even to identify ghosts. Each day, those same researchers might discover that they walked over their subject's resting place on the way in.

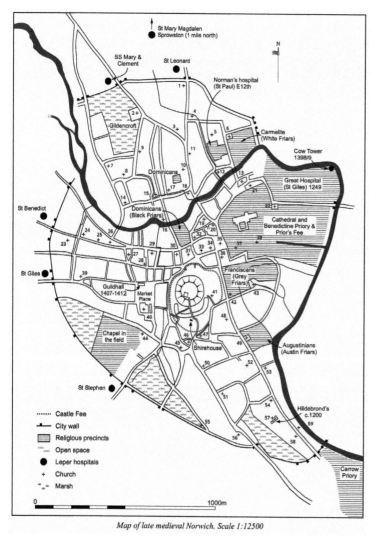

Norwich map showing locations of churches, leper hospitals and religious precincts in the late medieval period. (Courtesy of David Dobson, NPS Archaeology, https:// norwichmedievalchurches.org)

Map of late medieval Norwich. Scale 1:12500

Norwich's remaining burial grounds can offer a sometimes-wild beauty and a sense of peace the like of which cannot be found anywhere else in our fine city. Many of us visit those graveyards to pay our respects, or perhaps just to spend leisure time walking among the city's former citizens. Maybe there is something that pulls us to the calm of these 'gardens of sleep' – somewhere to contemplate our own lives in the company of hundreds, or even thousands, of past souls. But there are also graveyards we can no longer see (at least without reading the surviving clues) and those, too, supply their own fascinating stories.

Many readers will be familiar with Norwich's 'church for every Sunday' epithet, but this is quite the underestimation – just as it is for pubs for every day of the year. At least fifty-eight parish churches stood within the city's walls before the Reformation – it depends (as so often) on how and what you count. Were you to consider post-medieval or Nonconformist places of worship as well, the total would increase substantially. Of those fifty-eight plus, thirty-one are entire today, enough for Norwich to boast the greatest concentration of medieval churches north of the Alps.

The lost churches include somewhere between thirteen and sixteen lost during the medieval period. Another nine disappeared at the Reformation, and five more still during more recent times. When asked about the feelings the names of the lost churches evoked, suggestions included 'ethereal' and 'otherworldly': St Winwaloy, St Vedast, St Ethelbert, St Margaret in Combusto (or *ubi sepeliunter suspense*, 'where those who have been hanged are buried'), and St Mary Unbrent. In the case of St Olaf or St Olave (of which there were two) you might be forgiven for imagining Vikings making their way through the city.

Traces of some churches survive in street names, including St Botolph and St Vedast. Others are hinted at by buildings (St Cuthbert) or through surviving fittings; for example, Holy Cross Church's font is now at St Luke's, New Catton. Others still survive in records or boundary lines. For example, St Ethelbert was destroyed during the 1272 battle between city and cathedral; St Mary Unbrent and St Margaret Combust survived a fire, perhaps the sacking of the city in 1004, but were demolished in 1546–47 and united with neighbouring parishes. There are lost churches all over the city: under the cathedral and the Octagon Chapel, and outside Cinema City. Others lay beneath homes, parks and roads – as do their burial grounds.

The significance of St Margaret in Combusto's more grisly suffix is that criminals executed on a 'triangular hill where the gallows formerly stood' could be buried there, although the graveyard was used for others too.[24] Those who died or were executed at the castle were sometimes buried at St Martin-at-Bale (inside the bailey) until it was demolished in 1562. Later, some castle burials took place at St Michael at Thorn, although seventeen murderers are known to be buried beneath the modern Castle Museum, including the notorious James Blomefield Rush. A handful of other hanged murderers are buried at HMP Norwich, and at least one was buried at the city gaol, where the Roman Catholic cathedral now stands.

Among other lost churches are St Peter Southgate – now a playground; only part of the tower survived the demolition process when it stopped being used in the late nineteenth century – and, further in towards the city centre, what's left of the city's St Bartholomew on Ber Street. The church had been used for many things (as has St Mary the Less, which

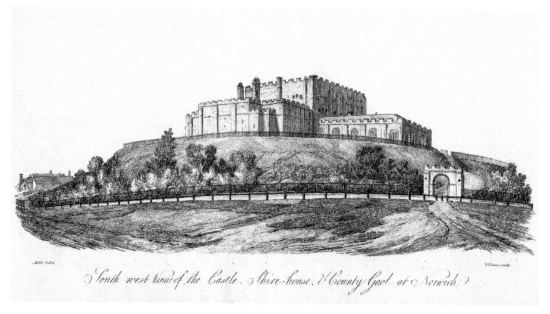

South west view of the Castle. Shire-house, & County Gaol at Norwich.

View of the county gaol at Norwich, 1810. Criminals were executed predominantly on the Hill or at Castle Ditches (now filled in). (Courtesy of Picture Norfolk)

The children's playground shown here contains the remains of St Peter Southgate Church.

is still visible on Queen Street if you know where to look), but most of the remains were removed in the 1950s. St Crowches (St Cross) is also worth a mention. Thought to have been entirely destroyed, the Hole in the Wall pub turned out to have been built inside the chancel – something discovered by accident when the pub was torn down to make way for Exchange Street in 1838.

St Andrew's Church is a place of contrasts, the resting place of paupers and goldsmiths alike. The burial register is studded with interments for men, women and children from the workhouse just down the road (at least until the closure of the churchyards and the building of a new workhouse close to the new cemetery in 1859). It is possible that deaths at the Bridewell could have led to burials at St Andrew's too, given its proximity, but sick inmates may have been transferred to city hospitals or lazar houses before they died. There is also evidence to suggest that some that died at the Bridewell were transported back to their home parishes – after all, the city's medieval churchyards have always been in close proximity. For example, Thomas Rants, aged one, who 'departed this life by the visitation of God, from smallpox, whilst with his mother in The Bridewell' in 1827 is buried at St Peter Hungate.[25]

Pressure on graveyards in the city began much earlier than the nineteenth century. Burial grounds were (and often still are) busy community spaces and meeting places as well as functional open areas. St George Tombland, for example, lost part of its graveyard

St Andrew's churchyard is within touching distance of the Bridewell, which still casts a shadow over the site today.

to stalls, and later shops, as early as the fifteenth century – you can still see buildings on top of what was the graveyard. Other churches, like St Simon and St Jude (without a tower since 1911), had to set up new graveyards in adjacent parishes when space was tight.

When walking alongside some city graveyards, the dead are not necessarily beneath your feet at all, but right alongside you. Take St John Maddermarket and All Saints, for example: the churchyards are banked up several feet above the pavement after centuries of interments. Next time you walk past you might notice that the churches themselves appear to have been built in pits, because the graveyards have risen around them after so many burials. This may well have been worse in the past, with this phenomenon apparently being noted as early as 1671.[26]

We've already come across the 'hints for public improvement' Chase published in 1783; he included suggestions for the city's burials too:

Another great evil to be met with here, and in most towns, is, the church yards being consecrated to receive the bodies of the deceased. This practice is not only inconvenient and displeasing, but has often been the cause of pestiferous disorders. The putrid state of certain diseases, and natural decay of bodies, contribute to an infection, by air and humidity, that operates (though imperceptibly) on the lungs. If burial grounds were appropriated on Mousehold Heath, and properly secured, the areas in which the churches now stand might be formed into handsome grass plats, both for use and ornament.

Buildings cluster tightly around St George Tombland (just one city example).

All Saints' Church, now dwarfed by its surroundings, is nonetheless surrounded by a walled-in churchyard that rises several feet above the pavement.

One wonders whether Chase would have approved of the 'handsome plat' outside St Gregory's Church today, on ground that was once its churchyard?

Somewhat later, in 1819, Norwich's beautiful Rosary Cemetery was established, but it was not an alternative to burial grounds on Mousehold, rather a solution to a different problem. Norwich had long been a centre of nonconformism, and the burial ground was a much-needed nondenominational space. It was ahead of its time and the first of its type in England. Thomas Drummond, a Presbyterian minister, was responsible for bringing the cemetery to pass, and it was his wife Ann, reinterred from the Octagon Chapel, who was the first 'resident' in 1821.

Unlike Chase's suggestion of levelling the walls, which never fully came to pass, municipal cemeteries *were* in the city's future – but not at Mousehold, and not for another seven decades. Norwich Sanitary Committee decided to move forward with the closure of some thirty-four churchyards in Norwich following a report by Mr William Lee, health inspector. Some of his findings are related below:

...any old burial-ground [that] has been turned over within 20 years is unfit for further interments, and ought to be legally closed forthwith, on grounds of health alone,

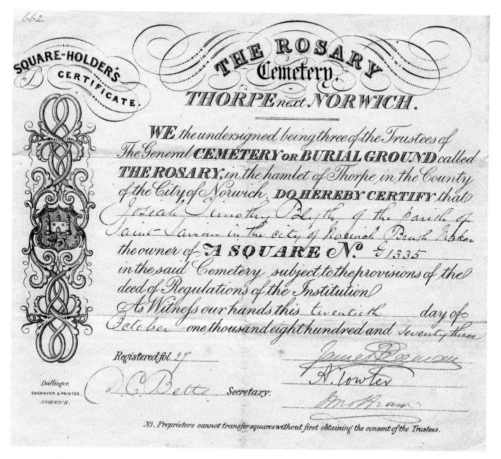

An example of a Rosary Cemetery plot certificate. This one is for Josiah Timothy Blyth of St Saviour, Norwich. (Courtesy of Norfolk Heritage Centre)

irrespective of those feelings of public decency which are outraged by the exhibition of the mutilated remains of friends, neighbours, and fellow citizens ... at least 20 out of the 34 burial-grounds within the city are in so crowded a state that no further interments ought to be permitted, and that in St John's Sepulchre, St Paul's, St James', and St Martin's at Oak, the ground has been entirely turned over within ten years, or half the minimum time necessary for decomposition...[27]

Lee's report particularly commented on the 'preventable disease and mortality in a city that ought to be one of the most healthy in the kingdom'.

The parish clerk of St John Sepulchre, at least, did not agree. His response to the *Norfolk Chronicle* stated that Mr Lee hadn't visited the churchyard, and if he had, would have seen that many parts had not been turned over for thirty years. There was 'ample room'.[28]

It took another two and a half years to advertise for sites, a couple of months after Queen Victoria's Principal Secretary of State, the RH Viscount Palmerston, made representation of an act to prevent new burial grounds opening in the city and county of Norwich, and discontinue burials in existing grounds from 1 February 1855.[29] The act covered not just parochial churches but also the cathedral, as well as some facilities for Nonconformists and Jews. It also extended beyond the walls to Heigham and Lakenham

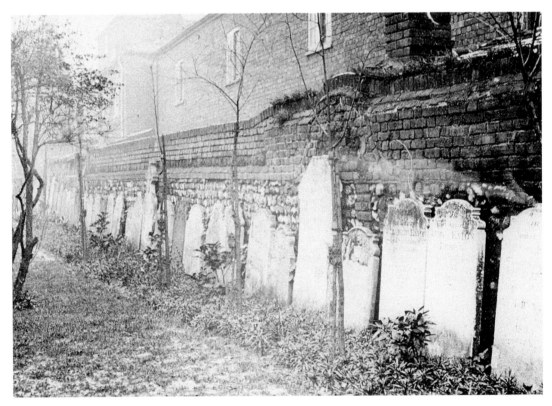

Headstones at St John de Sepulchre Church, from a nineteenth-century lantern slide. (Courtesy of Picture Norfolk)

(then hamlets), and suggested restrictions at the Rosary Cemetery (no burials within 10 yards of homes; one body in each grave). Burials within vaults were to be allowed in some places under some circumstances, explaining the reburial of Sir Thomas Browne's skull on 4 July 1922 at St Peter Mancroft, for example. (The register notes he was 317 years old, and had resided at Norfolk and Norwich Hospital Museum since the 1840s!).

Several possible sites were mooted, and some parishes initially let it be known that they would rather have a new burial ground to themselves. It was not until August 1855 that the Board decided that one new burial ground was the way forward, and many still had their concerns, citing the costs and hardship on the poor living furthest from the site. Many things had to be taken into consideration: transport to and from the cemetery by horse and cart, distance from the city, the prevailing winds, convenience for the majority of city parishes, drainage, soil type, annual mortality figures, city growth projections, and space for associated buildings, walks, vegetation and decoration.

The new cemetery was to be different to the churchyards, in a spacious edge-of-city location, laid out in planned sections, with much more thought given to prevailing opinions about public health. Advice published in local papers in 1855 said that graves should not be reopened for fourteen years after an initial adult burial, and that it should be possible for family members to be buried in the same plot, providing earlier coffins were not disturbed.[30] Such was the timescale between the act and the proposed closure of existing burial grounds that the city could not get its ducks in a row quickly enough. In the end, extensions were granted three times, and advertising for tenders for well-sinkers and nurserymen for the agreed site came in late 1855. Finally, 1 March 1856 saw an end to city interments and the opening of City (Earlham) Cemetery.

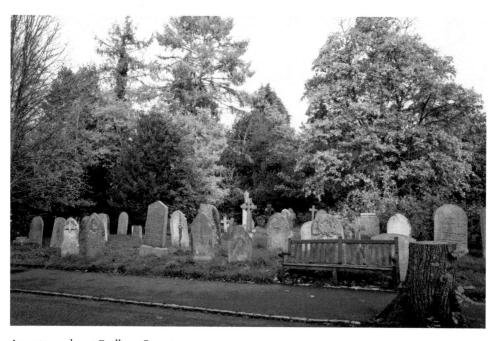

An autumn day at Earlham Cemetery.

Originally extending across 34 acres (of which 11 were initially leased to farmers), with both consecrated and unconsecrated areas, lodges, offices, and twin Gothic chapels, the site included a separate chapel and burial ground for Jews. Over the centuries, there had been Jewish burial places near the Haymarket (pre-expulsion in 1290), Horns Lane on the corner of Ber Street (*c.* 1750–1826), and Gildencroft (near Talbot Square) from 1813 until the closure of city burial grounds. Famously, in 2013, the remains of seventeen people believed to be victims of persecution and killed in the twelfth century were given a ceremonial reburial at Earlham. The Religious Society of Friends still use and care for their own burial ground at Gildencroft, which opened in 1670. In his report, William Lee notes that it 'is very large and apparently very little used' and as such, it was not closed along with other city cemeteries.

Over the decades City Cemetery has expanded several times and now includes a Roman Catholic chapel, a section for soldiers from Britannia Barracks, and, during the First World War, a new military area. The Baedecker raids of 1942 led to the digging of large trenches ready for more than 100 victims of the bombing in the city (see, for example, 'Captain Rowsell's Norwich' hosted at EAFA.org.uk).

The Jewish cemetery off Talbot Square, close to the Gildencroft Quaker cemetery. 'Property of the Hebrew Congregation 1840.'

Headstone for James Baldry and, much later, his wife, who was buried with him in 1892 when she died aged seventy-eight.

The twin chapels at City Cemetery were replaced with a crematorium in the 1960s as the proportion of people choosing to be cremated overtook that of those buried for the first time in many centuries. Despite the slowing of demand for burial space, questions have already been asked as to the future. In 2012, Norwich City Council announced that it had enough space for twenty-six years' worth of burials, and a planning application for a new cemetery in Drayton was refused by Broadland District Council.[31] At the time of writing, burial options vary from fifty years in a common grave with one space remaining, to 100 years in a brand new grave.[32]

GreenAcres Colney woodland burial opened in 1999, offering natural burial options. The site is open all year round and caters not just for the end of life, but for weddings, naming ceremonies and other events. The ceremonial buildings at the park are beautiful, modern halls with glass panels allowing the woodland to feel like part of the building, while the paths meander their way through trees, bluebells and foxgloves. Colney Park may be the newest place to be laid to rest close to Norwich, but it has quickly become a popular choice, and may prove to be how many of the citizens of the city choose to be remembered in the future. In a way it indicates a return to times when burial grounds were not just burial grounds, but places to play, meet and, indeed, live.

View within GreenAcres Colney woodland burial ground.

DID YOU KNOW?
The first burial at City Cemetery was that of James Baldry, who died from injuries he received after an accidental fall onto a water butt while working on one of its new chapels on 20 December 1855. Subscriptions were collected on behalf of his widow and children and the *Norwich Mercury* recorded contributions from the mayor, the chairman of the Burial Committee, several aldermen, councillors and key figures in the site's creation, as well as his employers and fellow workmen. (*Norfolk News*, 29 December 1855; *Norwich Mercury*, 12 March 1856).

DID YOU KNOW?
It was not unknown for men and women who took their own lives (*felo de se*) to be buried 'under the King's Highway' until the eighteenth century. Norwich newspapers report on Susannah Gooch who died in the mill dam (1786) and Susannah Warby who hanged herself in a privy at St Andrew's workhouse (1780). The last may have been John Stimpson, who reportedly hanged himself at the Bull Inn leading to a Sunday night burial under the St Benedict's crossroads (now Dereham Road/Old Palace Road/Heigham Road junction) in 1794.

Rosary Cemetery Chapel, taken from the end of the path off which the Drummonds are buried.

DID YOU KNOW?
The first burial at the Rosary Cemetery was that of Ann Drummond. She had first been laid to rest at the Octagon Chapel:

Saturday last [16 Oct], aged 41, Ann, the wife of the Rev. Thomas Drummond, of St George's Tombland, and daughter of Rev. James Pilkington of Ipswich. An event by which her husband is deprived of an invaluable friend, and her four children, too young to comprehend the extent of their deprivation, are bereft of a parental instructor, whose copious stores of information, and whose correctness of judgment, were well adapted to have afforded them many intellectual advantages. The interment took place yesterday morning.

(NC, 23 October 1819)

4. Upper Market

There are far more lost streets and buildings in Norwich than could possibly be covered in one book, let alone one chapter, so here we visit what was once where two of our key research centres – Norfolk Heritage Centre and Norfolk Record Office – now stand. The first sits within a central urban area within the city walls, above the modern marketplace, while the second stands on what was once a country estate, so they offer a nice contrast. Much of my working life has been spent at one or other site or nearby so the locations are therefore very much part of my personal 'secret Norwich'.

This chapter concentrates on the surrounding area as it was around 200 years ago, at a time when Norwich was just bursting its walls. Norwich Poor Law Union (and Registration District, which covered a similar area) had a population of 36,238 in 1801. It had barely changed by 1811, but would leap by 35 per cent to 49,705 by 1821. This historic unit covers a patch roughly equivalent to the ground bounded by the outer ring road to the north and east, but stretching as far as the boundary with Costessey in the west and Cringleford and Keswick in the south.

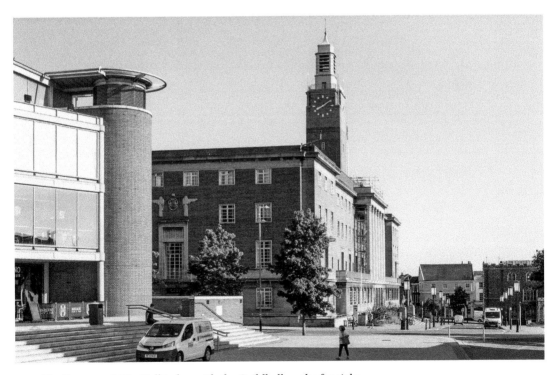

The Forum and City Hall today, with the Guildhall on the far right.

Reproduced below is a segment of a map of the marketplace and surrounds produced by Millard and Manning in 1830, a little after our timeframe. It clearly shows the city prison (top left), part of the castle (bottom right), and the reservoir in Chapelfield (centre left), which we have noted in previous chapters.

For this section's purposes, the map clearly shows the beginnings of development beyond the old walls to the west, and a street plan and urban area partially lost to modern eyes. Buildings encroach on the tower of St Peter Mancroft Church (bottom centre), and into the area we now think of as the war memorial and associated gardens. The market was once split into an Upper Market, the fish market, and the main or Lower Market. Additional lines show the (approximate) locations of today's Forum and City Hall.

The story from Manning to millennium is not as simple as one set of structures giving way to what we see today: there have been both piecemeal and large clearances in certain places at certain times. For now, let's imagine it is 1810/1. Christopher Berry has just published his trade directory, made famous in Mary Berry's recent episode of *Who Do You Think You Are* (fans: the actual copy Mary handled on the programme is held at Norfolk Heritage Centre), and you find yourself standing in the Upper Market, just in front of where City Hall now stands. Let's explore, while you breathe in a good whiff of fish.

The population of St Peter Mancroft parish, of which this area was part, has by now been fairly stable for well over a century: 1,953 parishioners in 1693, and around 2,300 in 1752, 1786 and 1801 (Berry's figures). People have been active here for the best part of a thousand years and it would be difficult to find a more bustling part of the city. The area is crammed full of market stalls, carts, people and goods. The city gaol has not yet moved

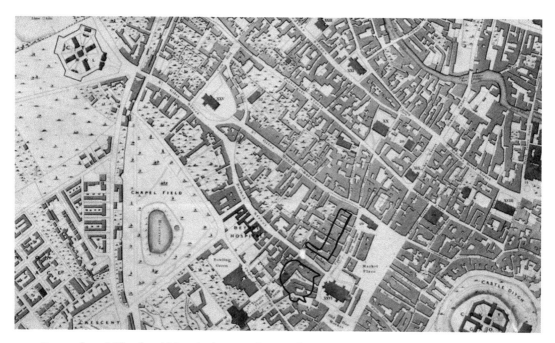

Extract from Millard and Manning's map of Norwich, 1830, with author additions. (Courtesy of Norfolk Heritage Centre)

St Peter's Street, viewed from the church tower prior to the construction of City Hall, *c.* 1935. (Courtesy of Picture Norfolk)

outside the walls and is currently situated opposite the Guildhall in a building that was, before 1597, an inn called the Lamb. The streets of the city are just beginning to be paved, since an act in June 1808, and lighting is improving but still poor. Davey Place doesn't exist yet – it will eventually run through the yard of the King's Head coaching inn on the other side of the market – and neither does Exchange Street, which will one day be blasted through at the northern tip of the market.

The Upper Market was home to the meat and fish market, hidden away from the main market by tall four-storey buildings. Getting between the two parts of the market involved going up Guildhall Hill or cutting through passageways: you can still do this in part by walking up Pudding Lane – a medieval word for offal. In 1810, the fish market retained an appearance that hadn't changed a great deal for centuries.

Berry listed several tradesmen on Upper Market (in later years many would take the address of St Peter's Street). An early nineteenth-century visitor would find Samuel Asker and John Woodcock, hairdressers; James White, William Beare and James Smith, boot and shoe makers; John Berry himself, printer and stationer; Brown & Son, ironmongers;

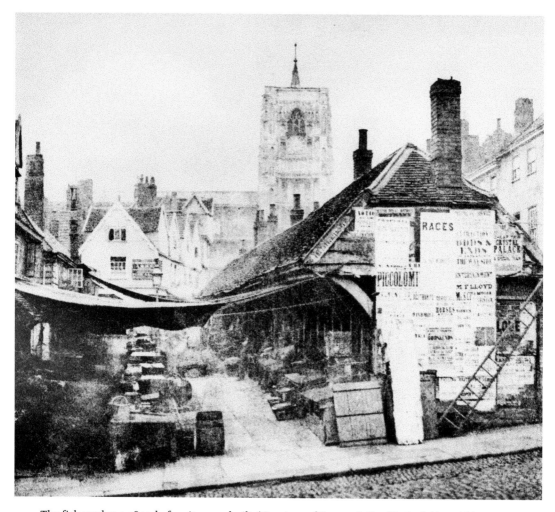

The fish market *c.* 1840, before it was rebuilt. (Courtesy of Barrett & Coe Limited, Norwich)

Elizabeth Brown, milliner; Peter Chamberlain and Culley & Co., grocers; Joseph Colman, baker; John Cousins, leather cutter; John Freeman, cabinetmaker and upholsterer; Widow Graham, breeches maker; Mrs Rivet, silk dyer; William Smith, plumber and glazier; John Wade, butcher; and a lodging house run by Mrs Green.

In addition, Berry listed publicans at the White Swan, Wounded Heart, the (Old) Church Stile and the Pope's Head, but there were more in our area of interest, including the White Hart and Wheatsheaf. In 1810 coaching inns like the White Swan were enjoying their golden age with swifter, more comfortable travel by coach than in earlier days, but no competition from the railway. Around 1810/1 the inn hosted large numbers of property auctions, meetings (for example the Amicable Society for Attornies), cockfights, concerts, theatrical performances and bankruptcy hearings. Berry listed John Sayer as one of the publicans there at the time, but, unfortunately for him, Sayer was about to be involved in his own bankruptcy proceedings.

The Wounded Hart (or Heart), which once stood on part of the City Hall site. (Courtesy of Picture Norfolk)

licitor, Norfolk Registry, Surry-street, Norwich.

TO BE SOLD OR LET,

With Possession at Midsummer next,

ALL that capital Freehold and well accustomed INN called the WHITE SWAN, situate in the parish of Saint Peter of Mancroft, in the city of Norwich, in which the most extensive business is now carrying on; comprising 24 comfortable bed-rooms, numerous servants' rooms and attics, 2 commodious dining-rooms, and 8 good parlours, coffee and travellers' rooms, 2 cooking-kitchens, a bar commanding a view of the yard and offices, and good wine-vaults and beer-cellars.

The out-premises adjoining consist of an extensive yard for carriages, stabling for 70 horses, hay-lofts, straw-houses, granaries, and out-houses, with every other requisite for public accommodation.

The Norwich Expedition and Lynn Coaches inn here, and the coach office forms part of the premises.

The above Estate has been lately put into complete and substantial repair, part thereof being now built at a considerable expence, and is well worth the attention of the public.

For price and further particulars apply to Mr. W. G. Edwards, Orford-hill; or to Messrs. Sewell and Blake, solicitors, Norwich. (1491

WITH POSSESSION NEXT MICHAELMAS,

Should you have liked Norwich in 1810 and wished to stay, the White Swan could have been yours in 1814. Detail from *Norfolk Chronicle*, 18 June 1814. (Courtesy of Norfolk Heritage Centre)

The Swan Inn continued to trade for at least another 150 years, but by the twentieth century the buildings were being used for other business. The historic buildings and undercroft were demolished in 1961 to make way for car parking.

Berry stated that, 'A gentleman desirous of spending a few days in Norwich, cannot help being gratified by seeing the various employments of its extensive manufactories in Stuffs, Cottons, Shawls &c.–the first and last of which are here carried to a perfection nowhere else to be met with in England.' However, times were changing, and as the textile industry slowed in Norwich and moved north, the city's workers turned to new opportunities – largely boots and shoes. Right here on St Peter's Street, James Smith's shop, which had begun producing a revolutionary product – readymade shoes – developed into a factory. For the first time standard-sized shoes were being produced in large numbers instead of being individually made and the industry boomed. While the factory remains were swept away to build City Hall and the police station in 1935, the brand name 'Start-rite', which eventually evolved from James Smith's original business, lives on.

Wounded Heart Lane (running parallel with Bethel Street) was also named for its pub (later known as the Wounded Hart, and, briefly, the Kitchener Arms). Its master, Mr Bessy, died late in 1810, so anyone looking him out having read his listing in Berry's directory, printed as a tool for 1811, would be disappointed. The lane hosted an engineering works later in its life before being cleared for City Hall.

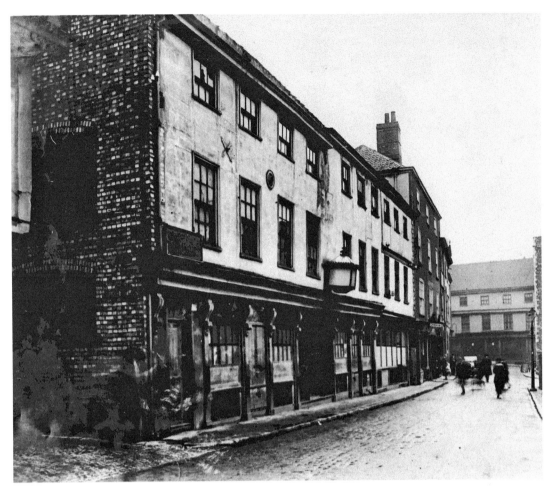

An early photograph of James Smith's factory. (Courtesy of Picture Norfolk)

Chapelfield Lane, now Theatre Street, had a well-to-do smattering of 'useful and interesting' listees: D. Freemantle, gentleman; Hewett's Lodging House; Ann Silke's Ladies' Boarding School; and Robert Wright, linen manufacturer. The area, as described in the first chapter of this book, maintained an air of respectability at this time, although it was beginning to fade.

Despite the more genteel areas, the area where the Forum and City Hall now stand was one of stark contrasts. The proximity of the marketplace brought everyone together in a hubbub of activity and, it has to be said, horse manure. For all the prosperous folk at the more respectable inns, there were multitudes of tradesmen above their shops and labourers moving into cramped yards. While in 1810 the yards were perhaps only just beginning to deteriorate into the worst of the inadequate, poorly ventilated housing familiar to our Victorian and Edwardian ancestors, the best days were over; the population was growing and development could not keep pace, leaving migrants to turn to homes through the narrow openings, particularly pub yards, that we know so well in Norwich.

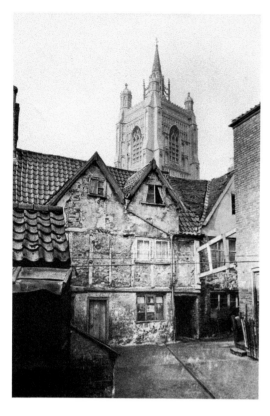

A nineteenth-century image of Mancroft Yard – taken from a lantern slide. (Courtesy of Picture Norfolk)

Things were very much less crowded on the modern-day site of County Hall. Back at the beginning of the nineteenth century the area was more or less open ground. In 1793 Philip Meadows Martineau purchased the estate as a retreat from his profession and built a 'small' house – he was then the principal surgeon at the Norfolk and Norwich Hospital. When his wife died in 1810, he remarried, became a father, and looked to improve on his house with a larger property more fitted to his improving rank and fortunes.

Famous landscape gardener Humphry Repton was the man behind the early nineteenth-century vistas from the soon-to-be villa, having created one of his well-known Red Books for the estate. The book is now held at Norfolk Heritage Centre as part of the Colman Collection. Repton's introduction asks that his volume be 'a tribute to the eminence you have acquired ... That the improvement of this Villa may tend to soften the anxieties of your profession and contribute to prolong a life, on which the life, health, and happiness of so many other depend'.

Repton went out of his way to design the estate to create an 'impression of retirement and seclusion from the bustle ... [as] there should appear a certain distance betwixt the house and the habitations of other men'. In this case, those other men were in Trowse. (It would still be fifty-plus years before the Colmans moved in and began their work to create a 'model village'; Trowse with Newton was then an outlying settlement, and quite a poor one at that). Repton's focus were the views from the proposed new house away from the city, down towards the south and east. These views would ideally dictate the 'situation'

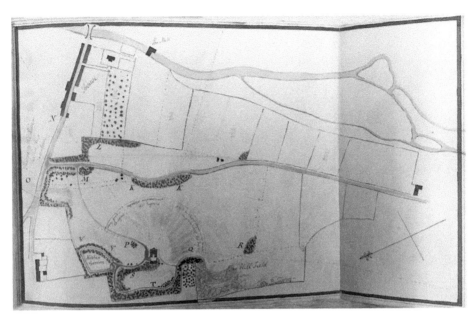

Plan from Repton's Red Book for Bracondale Villa. (Courtesy of Norfolk Heritage Centre)

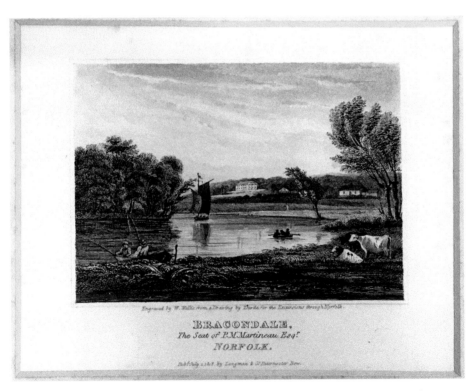

A colour engraving of 'Bracondale, the Seat of P. M. Martineau Esq'. (MC 2295/1, 946x1, Courtesy of Norfolk Record Office)

of the house, and the types and directions of the windows. The design of the house was entrusted to William Wilkins Snr, a native of Norwich, but the house didn't quite match what Repton had in mind.

By the time of the first edition OS maps, Bracondale Hall (otherwise known as Bracondale Lodge or Bracondale Woods) is depicted among parkland, with Martineau's Wood, a memorial chapel and 'Knucklebone Hall (Summer House)' all marked. The original grounds design included potentially acquiring 'the Hill Field', which appears to have been done. Repton felt the views here were not good, so Martineau, perhaps of his own accord, added some additional features to improve the area. Follies were all the rage among men of his circle at the time. Like many of his class, Philip Martineau was an interested antiquarian and collector. It is believed that he gathered together interesting historical remains and that some of these were from Carrow Abbey, not far away.

Visitors to the woodlands behind County Hall will know that an archway remains, perhaps part of one of the Martineau's garden buildings, a memorial chapel (also known as the Priory). It was potentially built with stone from Carrow Abbey around 1804/5. Knucklebone Hall Summer House, some evidence of which also survives, is rumoured to have had a floor made of knucklebones; other examples survive around the country using sheep, horse or deer bones – something of a fad in the eighteenth century. Neither is noted specifically in Repton's Red Book so it is unclear whether he or the architect, William Wilkins, was directly responsible.

The Priory was apparently broken into in 1822 and items including an album were stolen from inside.[33] Some decades later, a local newspaper notes that, 'The late P. M. Martineau, Esq., collected here many remnants of gothic architecture, and used them

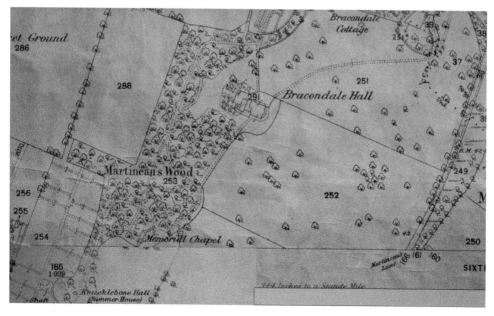

Extracts from c. 1885 first edition OS map showing Bracondale Hall and gardens. (Courtesy of Norfolk Heritage Centre)

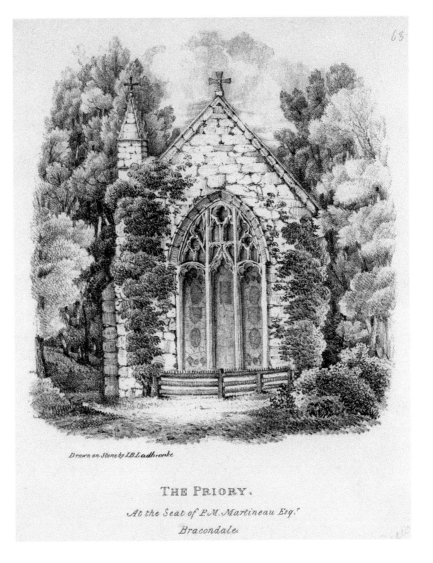

Drawn on Stone by I.B.Ladbrooke

THE PRIORY.

At the Seat of P.M. Martineau Esq.[r]
Bracondale

An engraving of
Martineau's Priory
by J. B. Ladbrooke.
(Courtesy of
Picture Norfolk)

in the erection of a lofty arch, and an edifice resembling a small priory, with windows of stained glass.' This rather suggests the arch and priory were separate, although other sources disagree.[34] Chambers included a description of the same remnant in his *General History: III* in 1829, describing the 'pointed arch ... forming an entrance through a sequestered walk, to an excellent imitation of an ancient oratory or priory'. The Priory was furnished and the 'album' stolen was perhaps the visitor guestbook or the Martineau family's collection of poems inspired by the surrounding scenery.

Martineau's home remained in place (although occupied by a succession of different people) until it made way for County Hall and the police station in the 1960s. Most of the gardens were 'obliterated'. Today, Norfolk Record Office, the source of several of the images in this book, occupies part of the old estate. Perhaps it is fitting that antiquarian Martineau's work is continued, in a sense, with their incredible collection of local archives.

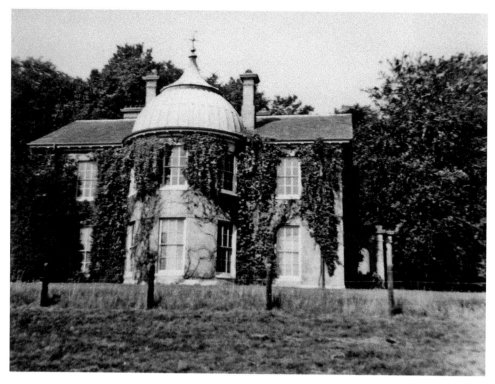

Martineau's house in 1963, shortly before demolition. (Courtesy of Picture Norfolk)

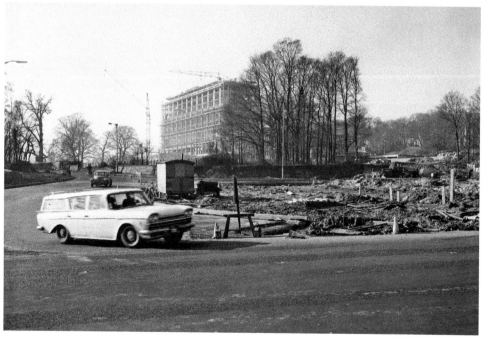

Construction on the County Hall site, 1967. (Courtesy of Picture Norfolk)

DID YOU KNOW?

Sayer's White Swan bankruptcy sale notice included: 'Forty beds, with rich chints [sic], moreen, and other furniture, excellent goose feather beds, pier glasses, in burnished frames, mahogany chests with drawers, neat sets of mahogany dinner tables ... handsome mahogany chairs of every description, upwards of 100 ozs of modern plate ... table and bed linen, two very large brass branches, with ten lights each, two dinner services, fine foreign china, soup tureens and dishes, three hundred dozen very fine old Port Wine, Madeira, and Claret, near 100 grose of glass bottles, and sundry other effects.' (NC, 24 September 1814)

DID YOU KNOW?

Humphry Repton was born in Bury St Edmunds in 1752 and later attended Norwich School, which today has a house named after him. Along with Bracondale, he also designed Catton Park (his first commission) and Sheringham Park (his 'most favourite' commission in 1812). Although letters survive at Norfolk Record Office with Repton's suggestions for Blickling estate, there is no evidence to suggest he provided any of these formally to the Suffield family. The bicentenary of his death is in 2018. He is buried at Aylsham.

DID YOU KNOW?

The old fish market was replaced with a relatively short-lived neoclassical pile in 1860. By then the previous market had been in operation for 600 years or more. It was a project that faced problem after problem. A worker died on site, and the surveyor was accused of taking bribes, which eventually led to his resignation. Less than sixty years later, the building was taken over with offices as the council expanded, and in the 1930s it was demolished along with several other properties to clear the ground for City Hall, which opened in 1938.

5. Plague and Pox

Many texts about epidemics try to put numbers to waves of illness, but the focus of this chapter aims to explore individuals and their wishes, stories, and beliefs. Probate and journal records feature here, among other fascinating items, because they are some of my favourite types of document. They can illuminate Norwich's past in a way that many other records cannot, bringing forth something of the character, hopes and fears of the testator or diarist in their own words. The experience of plague has an enduring fascination and myth, making it a perfect subject, and because I studied Norwich and its encounters with smallpox and vaccination for my master's dissertation, it was important to include that too.

Working in chronological order, it makes sense to begin with the Black Death of 1349. Numbers killed are debated, but it could have been more than half of the population – a huge proportion of England's second city of the day. Norwich has no confirmed pits or mass graves. Tombland is not named for tombs within it, rather 'tomb' (in its sense of being empty) refers to an open space, so is descriptive of an area where there was once a market.

Men like Henry, son of Nicholas le Clerk, were the immediate winners after the 1349 epidemic, able to take advantage of vacated manorial tenancies (i.e. parcels of land). Henry was admitted to several new copyhold land holdings in the manor of Eaton on the 'obiit' (death) of their previous owners, often where the previous tenant had 'nullus heirs' or 'ignorus heirs' – no, or unknown, heirs. Many areas of Norwich that we consider city today were rural manors only 200 years ago, let alone more than 600. Norfolk – city and county – has an extremely rich collection of manorial records relating to areas outside the walls. Large numbers are deposited in Norwich, others by historical quirk are further afield, but all detail land transactions, and, more than that, the day-to-day interactions between people and communities many centuries ago.

Within the city walls, a related spike in activity occurred. Meeres notes in his *History of Norwich* that invitations to take up the freedom of the city reached 120 men in 1349–50, compared to twenty-one the previous year. Meanwhile, there was an influx of new clergymen and prebendaries at Saint Mary in the Fields; a large number of cathedral monks had perished and most of the Dominican and Franciscan friars are supposed to have died too, potentially because their role gave them very close contact with the poor and sick.

One of my favourite items in the City Library collection at Norfolk Heritage Centre is a 1491 copy of the *Ortus Sanitatis*, (or *Hortus Sanitatis)*, roughly translated as the 'Garden of Health'. The volume, first published in 1485, is a compendium of plants and beasts along with details of their preparation for medicinal use. The colourful images deal with herbs, fish, birds, animals, and urine – and include such 'animals' as the dragon and phoenix. It includes an entry for theriac, regarded as a panacea, which was used to treat and prevent plague.

Right: Court roll from the Manor of Eaton showing Henry, son of Nicholas le Clerk, being admitted to new parcels of land. (DCN 60/9/3, Courtesy of Norfolk Record Office, Norfolk Record Office)

Below: St Andrew's Church, Eaton.

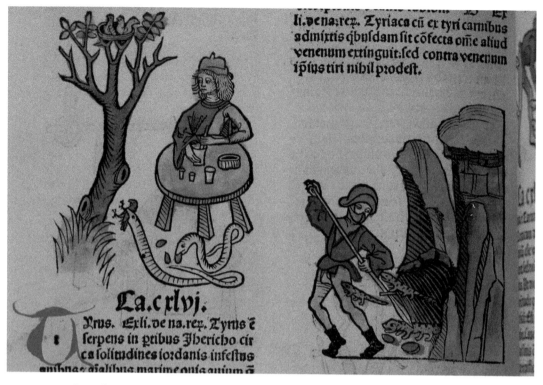

Extract from the *Ortus Sanitatis*, showing the preparation of theriac (left). (Courtesy of Norfolk Heritage Centre)

Theriac was expensive, but no doubt local entrepreneurs would have created their own tinctures for Norwich's worried citizens. Unfortunately, they were unable to hold back the epidemics, and great numbers perished or had their lives turned upside down during each outbreak between 1349 and 1666. Some city parishes were forced to enlarge their churchyards, and some documentation of this survives. St Peter Mancroft, for example, saw its burial ground stretched further towards the modern-day marketplace in 1368 – supposedly the path bisects the old and 'new' sections.

One of the people interred at St Peter Mancroft was Anne Beckett, buried there on 7 July 1666. A note of 'pla' in the margin of the parish register indicates her fate. July 1666 saw around fifty burials at St Peter Mancroft alone, more than five times the number during the preceding year. The surge in burials continued right through until November.

Anne's probate brings her story to life, as her last wishes were expressed while she was dying.[35] I include a transcription below retaining the original spellings:

Memorandum That on or about Friday the Seaventh of July in the
year of our Lord One Thousand Six Hundred Sixty & Six Anne Beckett late of
the Parish of St Peters of Mancroft within the City of Norwich Singlewoman being
sick of the sickness whereof she dyed with a mind to dispose of her Estate being
of p[er]fect mind and Memory did dispose of her Estate as followeth viz:- I give and

At St Peter Mancroft Church, this path is said to separate the 'new' extended burial area (on the left) from the original burial ground.

The burial of 'Ann Becket [sic], singlewom[an]' from the church burial register (second from bottom). (PD 26/16, Courtesy of Norfolk Record Office)

bequeath unto Jane Hawes the wife of John Hawes of the City of Norwich Butcher all that I have desiring her to provide a Coffin for me and did cast the Keys out of a Window to her and bid her to be take the Keys of what she had for that she had was hers after her Death or words to that effect In witness whereof we whose names are here undersubscribed have set to our Markes the one and Thirtieth Day of July in the year of our Lord 1666.

In a few lines, we hear from a woman desperate to be buried decently at a time when several funerals a day were already being performed in multiple city churchyards, even though the death toll of plague victims did not reach its peak until the end of August. A woman unwilling (and likely unable, by order as well as by physical capability) to let friends into her house – preferring to cast the keys into the street from her window – and a woman certain of her own imminent demise. If the dates given in the probate record and parish register are correct, then she was buried on the same day as her last wishes were expressed. I hope she received a coffin of some sort as per her last wishes. The fact that any record of probate exists at all suggests she may have had the means to purchase one, at least under ordinary circumstances. Anne's story is an individual link to a plague that, according to Blomefield at least, claimed 2,251 deaths from a total of 3,012 deaths between 3 October 1665 and 3 October 1666.

With the plague and the 'sweat' disappearing, later city epidemics were often related to smallpox, typhus and syphilis. Armstrong notes 'particularly grim years' for epidemics in Norwich in 1680–81, 1710, 1728–29, 1737, 1741–42 and 1747 (the highest number of burials in any single year of the eighteenth century) and definite smallpox outbreaks in 1805, 1807, 1819 and 1839.[36] Here, we're going to turn our attention to the last documented smallpox outbreaks: a public outbreak in 1871, and one confined to the prison in 1876.

In December 1871, Norwich was dealing with a significant smallpox outbreak, in the midst of a national epidemic that claimed around 45,000 lives between 1870 and 1872. In Norwich, the death toll was over 350, with a particular spike in the number of deaths in the March quarter of 1872 compared to the previous year. An 'iron hospital' that could be fitted up with forty beds was offered by the Marchioness of Lothian later that month and was erected on land close to the workhouse on Bowthorpe Road, land that is now just south of the Jewish part of Earlham Cemetery. The hospital had previously been used in London; local firm Boulton & Paul made similar products, even if they did not make this one. It was to remain in use for cases of smallpox until the new isolation hospital was built in 1893.

We can experience a personal view of the epidemic through the pen of Charles William Quevillart, a hospital sergeant who was based at Norwich barracks at the time. His journals (covering 1853–1903) can be found at Norfolk Record Office.[37] I include extracts below:

29 November 1871 – was disagreeably informed this morning that Small Pox was raging as an Epidemic in and Around the City, and several cases had proved fatal. This is one of the most loathsome ... diseases to which humanity is liable.

30 – St Andrew's the Scots Own are all on the spree, Egad! There'll be no small amount of Whiskey consumed today, on the other hand matters begins to assume a very serious

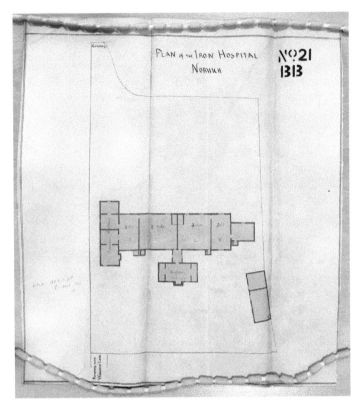

Right: Plan of the Iron Hospital, *c.* 1876. (N/HE 8/7, Courtesy of Norfolk Record Office)

Below: Site of the Iron Hospital within Earlham (City) Cemetery.

and grave appearance, that most detestable and much dreaded disease known as Small Pox is making sad havoc among the Civic Community

7 December – Just as I predicted some days ago, my fearful anticipation has been realised, Private Piddock was admitted to Hospital this morning with 'Secondary Syphilis' covered with Eruptions, and complaining with all the symptoms of Small Pox, but no suspicion crossed the Surgeon's mind, as the man had been constantly under treatment for Syphilis from which his constitution is fairly broken down.

11 – Trumpeter Wilson a lad of 16 reported himself sick

12 – A la fin! The Medical Officer came to the Conclusion that a well developed case of Confluent Variola ... in Private Piddock, he being blind and delirious with a head and face the size of an overgrown Pumpkin!

14 – Notwithstanding all treatment and care in nursing ... Private Piddock breathed his last at 4.15pm. I had his remains enveloped in a sheet and conveyed to the morgue, but a sad mishap occurred in transit, while descending the staircase, the bearers, a little unnerved, inadvertently let the corpse out of the sheet flop on the flag-stones opposite my living room door.

View of the cavalry barracks, c. 1900. (Courtesy of Picture Norfolk)

15 — The remains of poor Piddock were placed in the Coffin enveloped in a sheet saturated with Condy's fluid, and...conveyed to the Cemetery sans a single follower; this was all completed while the troops were out in Marching Array. The aspect is gloomy indeed for us poor mortals to be shut up in the Hospital, and nobody allowed to visit us.

16 — The news from the City this morning is quite Creve Coeur [heart chilling] death is still holding his 'Harvest Home'.

20 — A melancholy catastrophe occurred in the night in the City. A respectable Butcher carrying on business in Ber Street, suffering from Small Pox and in its delirious form... sprang out of bed, seized a poker and murdered his wife and family, then cut his own throat from Ear to Ear. How sad it is that there is no contagious Hospital for the unfortunate citizens.

[Hospital emptied and epidemic felt to be at an end]

10 January — Hoorah! ... so tremendous was my relief and so overwhelming my joy [after] the worry, anxiety and close confinement, that Hey-Presto donned my uniform and sallied forth to town by way of a change so much needed by my family.

Death records suggest that Private Piddock was twenty-four-year-old William Piddock, born in Wingham, Kent. The story about the butcher killing his wife and family has been

Norwich Castle.

rather difficult to back up. There appears to be no mention of such happenings in the local press, so it remains possible that the tale had been a little warped by the time it reached Quevillart's ears.

One more epidemic of smallpox was to come. The last epidemic occurred in Norfolk County Gaol (then at the castle) and was limited to twelve cases, including two deaths. The 1876 annual report of the Medical Officer for Health details the steps taken to contain the outbreak: a mixture of isolation and vaccination along with burning of clothing and bedding, and care from a warder and another prisoner who had already had smallpox. They were praised for keeping the disease isolated from the rest of the population.

Between 1853 and 1907 it was a legal requirement to vaccinate your child against smallpox. Across the country there was resistance against this, and Norwich was certainly not an exception. The majority of children were vaccinated and the large numbers immune almost certainly contributed to the disappearance of smallpox from the city (at least in epidemic form) after the 1870s. However, there were plenty of people

An example page from a Norwich petty sessions (or mayor's court) register, including a complaint against Richard King for not vaccinating his child, William. (PS 1/1, Courtesy of Norfolk Record Office)

opposed to vaccination as well as the principle of it being legally required. The concept of 'conscientious objection' – usually thought of in regard to the First World War – was actually coined in 1907 for those not wishing to vaccinate their children.

Several parents came before the city petty sessions at the Guildhall under the charge of not vaccinating their children, usually receiving fines and orders to vaccinate. They appear alongside all sorts of other crimes – drinking outside licensed hours, throwing snowballs, obstructing the highway etc. During the same year as the city's last outbreak, the Norfolk and Norwich Anti-Compulsory Vaccination Society was formed at an initial meeting at the Livingstone Hotel (Norwich's temperance hotel). The Burgess family were the hotel proprietors, printers of the local satirical and radical journal *Daylight* and heavily involved in both the temperance and anti-vaccination causes.

Dr Guy, public vaccinator for Thorpe and Norwich for a significant portion of his career, lived and worked from Garsett House on Prince's Street during the 1870s and 1880s and throughout the 'Norwich Disaster', when four children died following vaccination in June 1882. Their deaths prompted an inquiry and the subsequent proceedings occupied

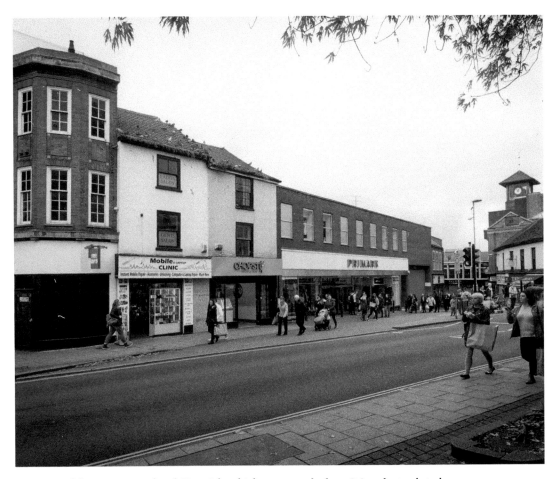

Site of the temperance hotel, Norwich, which once stood where Primark stands today.

Garsett House, city vaccination station in the 1880s.

many column inches across the country. Ultimately, it didn't find the vaccination process to be at fault, but something 'superadded to it'. Unsurprisingly, though, large numbers of parents were put off vaccinating their children that year, although a long-term shift cannot be pinned to the inquiry alone.

The process was gruesome by today's standards, requiring lymph from a vesicle on a vaccinated child's arm to be rubbed into scratches on the unvaccinated child's arm. While the procedure, when done correctly, might offer resistance to smallpox – a disease for which there still isn't a cure – it could also create a wound for other bugs to enter, either directly from non-sterile vaccination equipment or afterwards. The children who died in June 1882 had mostly been certified as having died from erysipelas, a serious bacterial infection of the skin.

We are lucky to live in, work in, or visit a Norwich that is no longer seriously afflicted with leprosy, plague and smallpox, but even our more recent ancestors were not so lucky. Many of the buildings in Norwich have connections to residents' health or sickness, and the records left behind help us to piece together the stories of those for whom the threats and consequences of deadly disease were only too real.

LAW, LYMPH, AND LANCET.

An image from *Daylight* (a former Norwich journal) in 1882, entitled 'The Vaccination Juggernaut', showing Dr Guy's head on a representation of Death. (Courtesy of Norfolk Heritage Centre)

DID YOU KNOW?

Not all lepers in medieval Norwich were poor. In 1448, a will was proved for Henry Wells (or Wellys) of 'morto leper per Cassus comorat extra portas civitate Norwici de Fybrggate'. Henry left money for a new chapel at the hospital on Magdalen Street where he lived. His executors, and some of his relatives, were also lepers and described as such in the will. (NCC Aleyn 9, Norfolk Record Office). The map in Chapter 3 also shows leper hospitals, which tended to be on the edges of the city, perhaps to isolate sufferers before they entered the most populated area (*see* p. 30).

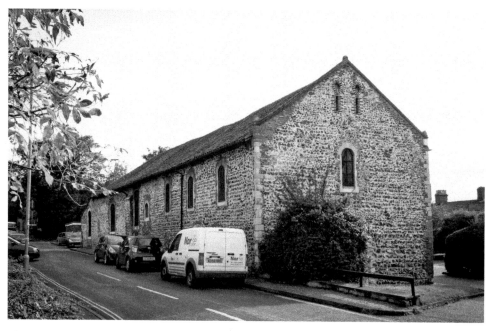

The Lazar House, once home to lepers and later a city library.

DID YOU KNOW?

It is still unclear what caused the 'sweat' or 'sweating sickness' that has become particularly associated with the Tudor era, but it may have been related to influenza. Norwich-born John Caius was a notable writer on the subject, having come into contact with it several times in the mid-1500s. He believed the illness was related to filth. Caius went on to become physician to several members of the royal family, including Elizabeth I, and, as well as a study on the sweat, wrote a book called *De Canibus Britannicis* ('The Dogs of Britain').

DID YOU KNOW?

Before Jenner discovered vaccination, it was already known that inoculation (also called variolation) could offer protection. This involved using matter from real smallpox vesicles. A healthy person would usually fight off the infection and recover. Unfortunately, it could still be passed on to others in the usual way, and those that could afford it sometimes unwittingly infected their servants. Briggs Cary, a Norfolk student in Cambridge, wrote in his diary in 1753 that his 'Apothecary could let me be nursed in his House ... it cost £30 [maybe £2,500 today]'. (BL/F 12, Norfolk Record Office).

6. Scroll and Script

There was always going to be a chapter about libraries and archives within this book; after all, I've spent the best part of a decade working in those institutions in the city of Norwich. Even with an enormous amount of change over the last few years we have facilities to rival the best in the country, and, at times, are judged to be the best in the country, at the very least in terms of visitor numbers and issues. Our libraries and archives are community spaces providing refuge for everyone; they are not just about books and documents, or even access to a computer, but are a hub of activity supporting health, wellbeing, heritage, education throughout life, music and the arts, and new business.

The history of libraries in the city is not as simple as 'Norwich Library' evolving from one original library step-by-step to what we see now. Instead, there has been a patchwork of institutions circulating material over the centuries – some private and some public (the latter both by subscription, and later for free). There was an element of competition between them and, as is the way of things, some flourished while others disappeared or merged with other institutions. Many still survive in one form or another.

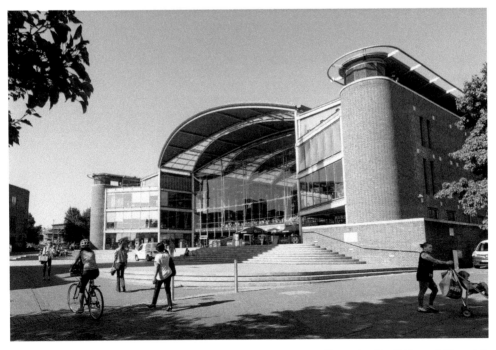

The Forum, Norwich, home to several organisations as well as the Norfolk and Norwich Millennium Library.

For thousands using the Forum today, the Millennium Library and other smaller city libraries are the only ones they've known. For those over twenty-five, memories may extend to the library's temporary location at Gildengate after the 1 August 1994 fire and, before that, the 1960s building that once stood on the Forum site (which also housed the county's first Record Office). Some readers will also remember the Duke Street library – the Free or Public Library – which closed its doors when the Central Library opened. These are probably the best-known libraries today, but are by no means the only ones to have existed in the city.

One of many 'firsts' that Norwich can lay claim to is the first public library under municipal control in England (outside London), which came into being on 3 May 1608. Norwich City Library was originally located in three rooms at the home of Jerrom Goodwyn, swordbearer. These rooms were in the porch of Becket's Chapel, by what is now Blackfriars Hall, and included lodgings for preachers wanting to consult the tomes (Becket's Chapel was made into a dwelling house at the time of the Reformation). To begin with it may have had only fourteen books.[38] While a 'public' library, the City Library still required members to be subscribers. The books belonged to the Corporation of Norwich and its predecessors. Over time the collection grew, and today many of the books survive within the City Library's special collection at Norfolk Heritage Centre (inside our current Norfolk and Norwich Millennium Library).

The Blackfriars themselves had a much older library prior to the Reformation, perhaps as early as the thirteenth century. They could borrow books but not own them. When Henry VIII's agents arrived they reputedly found only three volumes, the rest having been moved to safety. The City Library was established only sixty years after the death of

Becket's chapel was unroofed and largely destroyed in the late nineteenth century. This image was taken in 1972. (Courtesy of Jonathan Plunkett, son of George Plunkett, who took the photograph)

the king, whose reign and the period thereafter obviously included enormous religious upheaval, and the mission of the library at the time of its creation was to raise the quality of sermons preached in the city. Many of the books are Bibles or otherwise religious in nature, although other subjects are covered and not all members were theologians.

Philip Meadows Martineau, a gentleman we have already met, was largely responsible for the formation of Norwich Public Library in 1784. The initial subscribers were mostly well-off men of a good status in the city. Many were radical dissenters – something of a tradition in Norwich. In its early days the Public Library also used space at St Andrew's Hall, before moving to the disused Museum Court Roman Catholic Chapel on the site of the Duke of Norfolk's former Palace (left vacant because the 11th Duke, unlike the 10th, was of the Established Church).

In 1801, and again in 1815, after a period of complaints and a decade of removal, Norwich City Library was placed in the keeping of Norwich Public Library (at the time still a separate organisation), and the books fell under the same rules as those within the Public Library. 'A Catalogue of the Books Belonging to the Public Library and to the City Library of Norwich' (1825) contains a list of these rules ahead of the catalogue. Two of my favourites are 'XXXVIII' and 'XLVI', here transcribed respectively: 'Subscribers living in the country, whose books do not fall due on a Saturday, shall be permitted to keep the books until the Saturday next after the day on which they become due,' and 'No person, without a written order from the president, shall be permitted to take down any books from the shelves, but shall receive them from the Librarian. The fine six-pence for every book so removed.'

The City Library is now a treasured special collection at Norfolk Heritage Centre inside the Millennium Library. The author is lucky enough to work with the collection!

Norwich Public Library did not retain its place as the single most exclusive subscription library in Norwich for long. In 1822 the Norfolk and Norwich Literary Institution was set up to address concerns about the inferior works, lack of standard texts and time between publication, and accession to the library catalogue at the former establishment. Shortly thereafter, the Norwich Public Library Committee acquired the site of the old city gaol on Guildhall Hill and built the impressive columns that remain today. Pevsner describes the building as having 'a strange, inside-out appearance'.[39]

As the nineteenth century progressed Victorian reform gathered pace. In the spirit of providing opportunities for self-improvement and education, the Public Libraries Act of 1850 brought with it the power for local boroughs to establish free public libraries. Norwich was in the vanguard of authorities to adopt the act, and while Winchester opened its library in 1851, the first municipality to adopt the act and open a new building entirely funded under it was our own city, which threw open the doors of the public library, museum and art school on 16 March 1857 (albeit gently and without a great deal of fanfare from local dignitaries, or, it must be said, the *Norfolk Chronicle*):

NORWICH FREE LIBRARY ... on Monday last this new institution was opened ... Throughout the day, the spacious rooms were filled with people, to whom the books they required were supplied. The committee intended that the opening should be duly

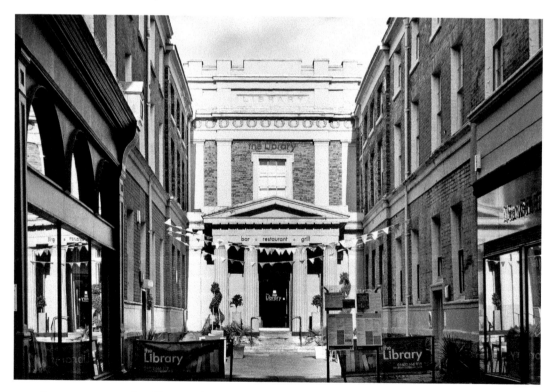

Now a restaurant, the old Norwich Public Library building (later the Norfolk and Norwich Public Subscription Library) can still be found opposite the Guildhall.

celebrated ... but on account of recent political changes the celebration is postponed till a future opportunity ... the new building ... is in the Italian style, and it is admitted to be a very handsome edifice, quite an ornament to the city. There has been an erroneous impression among the citizens that the whole building is for the Free Library but it includes accommodation for the Museum, Literary Institution, School of Art and a public lecture-room. The library has been entirely formed from voluntary contributions, either of books or money.[40]

The laying of the first stone was a rather more conspicuous event:

Invitations to a considerable number of the gentry ... and handbills were extensively circulated ... but we believe very few persons anticipated such a gathering ... The Independent Order of Odd Fellows ... assembled and marched with a band, flags and banners to the scene of the ceremony ... The yard adjoining the museum [NB: the museum moved to the castle in 1894] was gaily decorated with arches of evergreens, flags and banners ... St Andrew's and Duke's Palace streets were crowded with people. Some parties, determined to have a good view ... got on the wall at the corner ... till the corner gave way with those upon it. They of course fell with it, and several persons were seriously injured ... Sir S. Bignold addressing the company said ... We hope that the Free Library will hereafter prove an inexhaustable source of intelligence and usefulness to the classes for whom it is designed – the working classes of Norwich.[41]

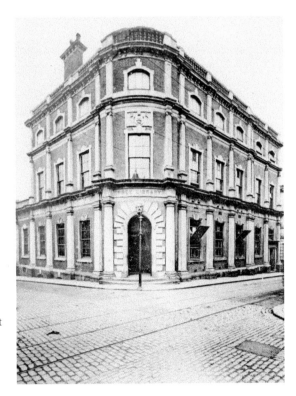

The Free Library on the corner of Duke Street and St Andrew's Street from a lantern slide, now replaced by modern buildings and St Andrew's multistorey car park. (Courtesy of Picture Norfolk)

Between 1857 and 1862 there were wranglings between gentlemen about where the City Library collection should reside. The Public Library apparently used 'every tactic to retain the books' but in the end the collection moved to the Free Library. They have remained there ever since, moving from Duke Street to Bethel Street, and returning after the fire to the new building on Millennium Plain.

Former rivals Norwich Public Library and Norfolk and Norwich Literary Institution co-existed until 1886 when they merged, forming the Norfolk and Norwich Public Subscription Library in the Guildhall Hill building. The new organisation was custodian of around 70,000 volumes serving between 600 and 700 members – not a great deal more than in the early nineteenth century.

Just over a decade later, the other library fire – of 1898 – which coincidentally also occurred on 1 August, caused significant damage to the building and destroyed much of its contents. This fire, which started on the premises of Daniel Hurn, ropemaker, and spread along the street, is obscured by the more recent one but was nevertheless instrumental in dictating which volumes now survive for historic research.

THE GREAT FIRE. This morning the scene of the great fire was visited by considerable crowds, but as the approaches were all blocked by the police, they had to content themselves with such distant views as were obtainable from the Library Court, the end of Dove Street, and the corner of Lobster Lane. At the Norfolk and Norwich Library

Bookplate from the 'United' Norfolk & Norwich Library, Guildhall Hill. (Courtesy of Picture Norfolk)

there was a constant succession of visitors ... Mr Bolingbroke expresses the hope that the literature and the transactions of the body may be recoverable ... The Norton Library has absolutely disappeared. It contains, probably, no volume capable of re-binding. The apartment below however, where the principal works of a scientific character were stored, has not fared quite so badly. Looking through the windows there are many volumes which appear to have suffered only from smoke and water.[42]

This is notably similar to the reporting after the 1994 Central Library fire, where, again, physics dictated that the fire went up and the water went down. Large numbers of volumes and documents in the basement were smoke and water damaged, but nevertheless survived.

NEW CLOCK FOR THE LIBRARY. The clock at the Norfolk and Norwich Library had a particularly warm time on the occasion of the great fire three weeks ago. The woodwork of it was utterly consumed, and the face was scorched to a rusty brown. In spite of the difficulties and the excitement of the occasion, it manfully endeavoured to fulfil its duties. By half-past seven, however, when the fire had been raging about half an hour, circumstances had become too much for it, and it gave its last expiring tick. One blistered hand still points to the hour ... the other has disappeared, probably swept away by the tremendous vigour of the Carrow hose. Mr Edward Holmes, jeweller, of St Giles's Street, has generously offered the Library a new clock, to be presented as soon as the derelict premises have been refurbished, and in the meantime, he is lending a clock for use at St Peter's Hall, where the library continues in some limited fashion to be carried on.[43]

The temporary record office search room at Gildengate House in the late 1990s. (Courtesy of Picture Norfolk)

So, also in 1898, a city library found itself in temporary premises. However, it managed to reopen in its Guildhall Hill premises on 2 August 1899, almost a year to the day of the fire. The library's façade was saved but the inside of the building was almost entirely recreated under the eye of contractor Mr Yelf and city architects Messrs Boardman & Son. 'Several waggonloads' of books were consigned to the Corporation as refuse, but 3,000 were rebound and another 3,000, out on loan, were returned.[44] Thankfully the city's population has always borrowed lots of books!

The Free Library and Subscription Library operated concurrently in the city for more than 100 years – serving their customers, curating, and expanding their collections. The free libraries movement gathered strength as new branches opened around the city and county, with particular expansions in the 1920s and '30s and the 1960s as new developments demanded community facilities. The Subscription Library finally closed its doors in 1977, with many items going to Norwich School and others finding their way to the 1960s-built Central Library, and subsequently, Norfolk Heritage Centre.

The Central Library rose from the ground during 1961 and 1962 and was formally opened by the Queen Mother on a freezing cold 19 January in 1963. The building was most certainly 'of its time' and, like its replacement, was somewhat controversial in its design. Whether, in your opinion, the building itself was beautiful or not, the city took the symbol of the library, its contents, and what it meant, to its heart and several describe its subsequent destruction on 1 August 1994 almost as a bereavement. Friends remember

Taking tea in the Subscription Library, 1960. (Courtesy of Picture Norfolk)

Dignitaries inspect the design for the new Central Library. (Courtesy of Picture Norfolk)

The mosaics depict the history of the written word – from clay tablets through hieroglyphics, illuminated manuscripts, the printing press and a librarian helping a child to read.

how they used to worry about coughing or sneezing in the old, quiet, reference area, how they threw money in the fountain, and how they loved the old (possibly haunted!) stacks. The original Central Library mosaics, created by Laurel Cooper, have recently been restored, and were reinstalled at Norfolk Heritage Centre in August 2017.

It is a common misconception that many Record Office archives were lost in the 1994 fire (they were kept in the basement strongroom and therefore water damaged, but salvageable), but it is true to say that many volumes from the local studies reference collection were destroyed. Having said that, some of the most important items remain such as the Boleyn Bible, the Norwich Apocalypse, and large numbers of items from special collections. The modern electronic stack still houses everything from bound newspapers to first-edition local literature, sale catalogues, and the Norfolk Photographic Survey, which began in 1913. There is a unique collection of First World War soldier portraits, the country's earliest medical photograph (a gall bladder!) and more than 11,000 maps. The library and its collections have risen from the ashes to become, arguably, as good – if not better – than they were before.

Norfolk and Norwich Record Office, headed by Jean Kennedy MBE, who remained County Archivist until March 1997, was first given separate status on 1 January 1963. Until then archives had been accepted into library collections, while others had been held in the castle muniment room or in separate stores at courts, councils, offices, and private hands. After 1994 the records went through two major moves, spending time in the temporary Gildengate Library premises before eventually moving to a new, much larger, site next

The original electronic stack at Norfolk Heritage Centre in 2014, home to most of the library's local studies resources.

The Archive Centre, one of the strongrooms at Norfolk Record Office. (Courtesy of Norfolk Record Office)

to County Hall, opened by the Queen on 5 February 2004. The strongrooms in operation there today are larger than the castle keep. The Archive Centre houses not just Norfolk Record Office, but the East Anglian Film Archive and Norfolk Sound Archive.

Another unique library that suffered in 1994 was the Second Air Division Memorial Library. It was established as a living memorial to Americans of the 'friendly invasion', who flew from airfields in East Anglia during the Second World War. The library also acts as a symbol of education and friendship between the UK and the USA. Dedicated in the Central Library on 13 June 1963, the library lost uniforms, photographs and books in the main part of the library to the flames. The records in the basement survived, however, and the Memorial Library was reopened inside Norfolk and Norwich Millennium Library on 1 November 2001.

Norfolk and Norwich Millennium Library is currently the hub of a countywide service of forty-seven libraries including branches at Earlham, Hellesdon, Mile Cross, Plumstead Road, Sprowston, St William's Way and West Earlham. Until 2003 there was also a branch in the Lazar House, a former leper hospital reputed to have been the country's oldest library building (*see* Chapter 5).

The city has moved on and away since the last fire, forging a new story, but it will be a long time before memories fade. In more recent years the twin phoenixes of the library and record office have come to exemplify modern library and archive services. The former spent seven successive years as the busiest library in the country – one part of a dynamic, evolving, service. The latter has been at the forefront of digitisation, outreach

The modern Second Air Division Memorial Library, on the ground floor of Norfolk and Norwich Millennium Library.

Conservator Yuki Russell with the Norwich Bomb Map, which features 679 paper labels marking the locations where bombs fell between 1940 and 1944. (Courtesy of Norfolk Record Office)

and conservation, with well-publicised stories including the conservation of the Norwich Bomb Map and the Apocalypto Project (the virtual unrolling of a fused-together scroll through 3D x-ray techniques that picked out iron and copper in medieval ink).

Even in 1850 many voices decried the need for a library service. In 2017, libraries still need to fight for recognition and survival. What the future holds for the next part of the library story remains unclear.

DID YOU KNOW?

There is another beautiful historic library at the cathedral, with a modern reading room that was completed in 2004. The library incorporates the collection of the Dean and Chapter, the library of the Lincoln Theological Institute, and special collections including the Brian Runnett Music Library and the Norwich Diocesan Association of Ringers. The library also provides a base for the Norwich Centre for Christian Learning. It is open to the public during its normal opening hours.

DID YOU KNOW?

When printing presses were reintroduced in 1701, Norwich also claimed the first provincial newspaper, the *Norwich Post*, and then saw a boom in newspaper production. The city still houses archives of many of these at Norfolk Heritage Centre. The city was a centre for booksellers and publishers and was home to several small circulating and subscription libraries throughout the late eighteenth century and into the nineteenth. Norwich's literary history, its centuries of enquiring minds, and thriving modern reading and writing scene led to Norwich's status of UNESCO City of Literature – another first for England – in 2012.

DID YOU KNOW?

In a long list of members of the 1825 Public Library, I was delighted to find my own distant aunt, 'Miss Walne of Whitlingham', whose name is printed beside many other Georgian citizens. She was something of a minority as a female (women appear to make up less than 10 per cent of members, honorary members and committee). It is possible that she once borrowed some of the very volumes held at Norfolk Heritage Centre today, although in her time the librarian was, of course, a man – Mr Richard Langton.

7. Aerostatics and Acrobatics

Assize Week was a celebrated feature in many towns and cities, and Norwich was no exception. It was the week during which the travelling assize court, which tried crimes that could result in a death sentence (of which there were once many), arrived. While the visiting court dispensed justice, the population of Norwich enjoyed concerts, fireworks, breakfasts and all manner of other entertainments in the mid-August sun. It was during this 'gayest period known to the inhabitants' that the pleasure gardens did their greatest business, along with special occasions like Guild Days.[45] Like the assizes and their associated diversions, though, the gardens have gone.

A nineteenth-century broadside ballad singing the praises of Assize Week at Green Hills. (Courtesy of Picture Norfolk)

The gardens in Norwich, while perhaps not as diverse as those in London, were nevertheless host to a wider social mix than many other city establishments. In ten years, not a single searchroom visitor has asked me about them. It is probably not a coincidence that the final winding down of Norwich's principal pleasure gardens occurred just before photography took off; images of the gardens, beyond maps and prospects, are hard to come by, and the venues themselves have faded from living memory, leading to their relative obscurity today. This chapter focusses on the most prominent gardens during the height of their popularity – a small part of a much longer and more varied history.

It's 1776. George III is on the throne, and America has just declared independence. The three principal pleasure gardens in Norwich – then known as Bunn's Spring Garden, Quantrell's Rural Gardens and The Wilderness – are going head to head, and adverts in the local news ahead of Assize Week compete for the attention of Norwich's residents. Pleasure grounds are enjoying their heyday, offering amusements to anyone with the required entry fee, and always looking to outdo one another in the novelty stakes.

James Bunn, formerly of the Theatre Royal where he was involved in set design but now of the Spring Garden, is offering 'breakfasting, illuminations and other exhibitions'. He has engaged a martial band and his competitor's head engineer for technical wizardry. Still in his early reign at the Spring Garden, he has asked the public to look on this year's events as the best presently in his power, hinting that he has substantial plans for future years.

William Quantrell is hosting his fourth season at Quantrell's Rural Gardens. Like Bunn, he is offering 'the usual' concerts and breakfasting, illuminations (many of which were 'grand and capital pieces' by an Italian artist) and a conclusion of 'the taking of

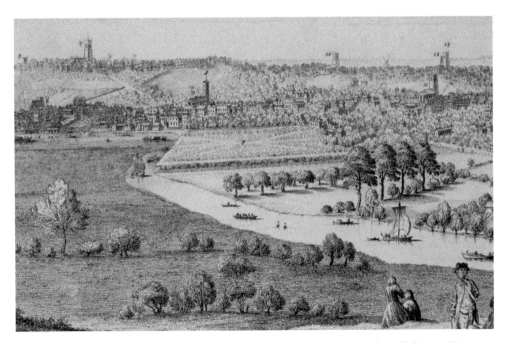

Part of a south-east prospect of Norwich showing the Spring Gardens (numbered '9'), 1741. (Courtesy of Norfolk Heritage Centre)

Bunker's Hill, with Fire Ships, and a great Confusion Of Bombs and Musketry' by way of an explosive finale. The real Battle of Bunker Hill had taken place during the siege of Boston the year before. A note at the end adds that he too has arranged a military band, a nod to the competition between Norwich's gardens and their proprietors.

Joseph Hammond, at The Wilderness, off Ber Street, is countering with yet more breakfasting and illuminations, the band of the East Norfolk militia, and 'a Piece of Machinery representing a Sea Fight with five Ships, &c. The Method for storming a Castle, and a View of the Sea, with Mermaids, Dolphins, Tritens, &c. With beautiful Transparent Paintings, representing a Sea God drawn in a triumphant Car: The whole to conclude with a curious Collection of FIREWORKS'.[46]

Any one of them must have offered quite a sight. Illuminations were a huge draw in a world before electricity; it is difficult in modern times to imagine how wondrous the effects of hundreds, if not thousands, of small coloured oil lamps strung among the trees and around the promenades must have been, let alone the steampunk-esque automata and the results of the ever-developing field of pyrotechnics that brought new wonders each year.

Perhaps due to its status and proximity to the capital, Norwich had followed London's craze for pleasure gardens early on. It probably helped that the city was already known as a verdant one, with open spaces and the influence of Huguenot market gardening. By 1664 Henry Howard (6th Duke of Norfolk) had already laid out a garden on the site of the Austin Friary, which was demolished in the sixteenth century. Sir Thomas Browne notes in his journal that he spent Christmas in Norwich and Howard had 'lately bought a piece of ground of Mr Mingay ... which he intends for a place of walking and recreation ... [he

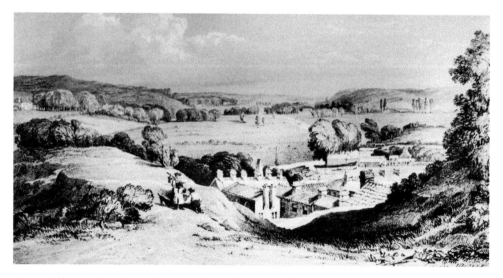

Merry-Making with a View of Norwich, From Richmond Hill Gardens by Robert Ladbrooke, *c.* 1816, is thought to be the only surviving depiction of a Norwich pleasure garden, but it has not been possible to locate an image of the painting. Instead, here is an engraving of the valley of Thorpe from a viewpoint on Butter Hills, where Richmond Hill Gardens would eventually come into existence. (Courtesy of Norfolk Heritage Centre)

further plans] a bowling green, a wildernesse ... and a garden'.[47] In 1680 it was said that, 'The last assizes there was a concourse of women at that they call My Lord's Garden in Cunsford, and so richly dressed, that some strangers sayd there was scarce the like to be seen at Hide Park.'[48]

'My Lord's Garden', as it was known for a long time, was ideally to be approached by boat along the Wensum from the Duke's Palace, which once sat between Charing Cross and the river. The garden extended from Conisford Street (later King Street) to the Wensum; the new St Anne's Quarter sits on top of it, not far from Dragon Hall. While smaller than its later rivals, the garden appears to have remained competitive right up until 1776, when it is conspicuous by its absence from the *Norfolk Chronicle* adverts referenced earlier.

Spring Garden (earlier known as Moore's Garden) dates from around 1739. Originally, it catered for genteel crowds looking for a place to stroll and appears to have the distinction of being run by a woman for a while – John Moore's widow looked after it for a time after his death. The gardens were not so very far from My Lord's Garden, in the area between Mountergate and the river – now the site of offices and the Norwich Nelson Premier Inn.

Bunn, bringing his creative theatrical experience, grew the influence of the gardens to rival the biggest that would come on the scene, providing one novelty after another. He built a rotunda called the Pantheon (helping him avoid losses due to the weather and to extend the season) that had an auditorium big enough for 1,000 people. The Spring Garden was later taken on by John Keymer, who in turn brought his own developments and renamed the gardens the Vauxhall Gardens after the famous London equivalent. Keymer retired abruptly in 1799 and the gardens seem to have retired with him.

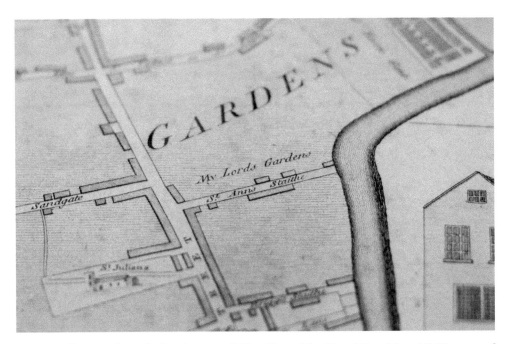

Location of 'My Lords Garden' as shown on 'A New Plan of the City of Norwich, 1766'. (Courtesy of Norfolk Heritage Centre)

St Anne's Quarter, with Dragon Hall to the back left and the River Wensum to the right.

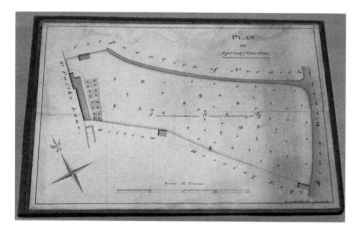

Plan of Spring Garden by W. Millard, showing the site's location between St Faith's Lane and the river. (BR 35/2/50/4, Courtesy of Norfolk Record Office)

The Wilderness had several relatively brief incarnations under various names from 1748, but success was generally short-lived despite the site's wonderful views. Wrestling was advertised there at one time in what could be argued to be a comparatively more down-market offering than elsewhere. The grounds occupied a slope on part of Butter Hills, near the Ber Street gates.

The 'Wilderness' of this period was somewhat different to the modern sense of the word. The Georgian Wilderness (which gets more than one nod in the works of Jane Austen) was of a planned rather than entirely wild nature, with diagonal and serpentine walks meeting at angles among the trees, providing manicured woodland promenades.

Today, part of the site is still a wooded slope and the name survives in the Bracondale 'Wilderness Walk', which falls from Carrow Hill to Alan Road. The western end of the grounds was opened for a spell as Richmond Hill Gardens, but those too disappeared and Victorian houses were later built. Plans for a public park on the site were abandoned in the 1920s.[49] A gateway, now blocked, in part of the surviving wall is believed to have been an entrance to the pleasure gardens.

Finally among the principal lost pleasure gardens, we arrive back at Quantrell's Gardens. Beginning life as Smith's Rural Gardens *c.* 1766, it had been a development for Widow Smith's horticulture business – she sold trees, shrubs and bulbs. Quantrell took over from her around 1772 and was one of a succession of proprietors to carry on the business until 1849 under one name or another. Quantrell put in a new 'commodious' entrance opposite the old Norfolk and Norwich hospital for ladies and gentlemen in their carriages. Admittance was 1*s* 6*d* in 1789 – 'returned in liquor, &c'.[50]

The gardens were just outside the city walls and indeed just outside St Stephen's Gates, which still stood when the gardens first opened. The pleasure grounds stretched all the way from St Stephen's Street to the area now Sainsbury's on Queen's Road, and from Queen's Road to what is now Victoria Street. First (almost) lost under Victoria Station, the site has since been cleared of most remnants of the railway, too.

Under Mr Neech, then Mr Harper and Mr Finch, under whom the gardens were named 'Ranelagh Gardens' and later the 'Royal Victoria Gardens', the venue became the primary pleasure garden in the city, partly because the other gardens fell away. Our friend Christopher Berry, writing in 1810, tells us that it was the 'principal place of Summer-amusement and resort'. By the early 1800s there were several buildings capable

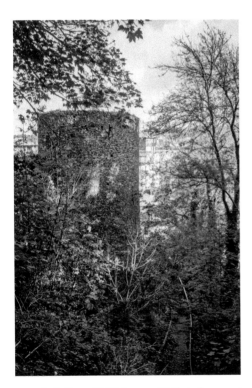
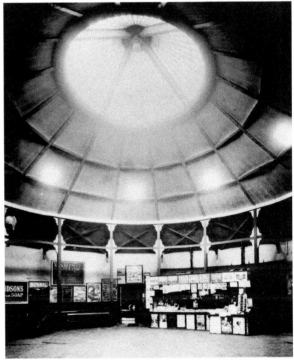

Left: Part of Wilderness Walk today, passing the 'lower tower' (i.e. below Black Tower).

Right: Part of the former pleasure gardens was retained when Victoria Station opened its ticket office in one of the buildings, the 'new' Amphitheatre, which had probably replaced the original erected by Quantrell in 1792. (Courtesy of Picture Norfolk)

of hosting crowds of 3,000 or more for evening entertainments, which ranged from orchestral performances to high-wire acts and acrobatics, dancing troupes, equestrian shows and pyrotechnics, as well as patriotic spectacles including a 'moving panorama' of Nelson's funeral.[51]

One of the pleasure gardens' principal claims to fame was a brief spell of hot-air-balloon mania. The first manned balloon flight took place in France in 1783, but the craze reached Norwich quickly. By October 1784 so many small balloons were being constructed that the city authorities, terrified of the associated hazards, threatened prosecution to anyone causing damage.

It is through the balloons that the pleasure gardens connect to Whitlingham, still a much-loved leisure place for the city even if, technically, Whitlingham's Great and Little Broads sit outside Norwich. While the Broads were of course not there, the area around Whitlingham St Andrew Church, to the eastern end of today's Country Park, was already a popular place to visit in the early 1800s. The Victorians were great ones for romantic

Part of Quantrell's site today – offices and homes.

SURGEON, at AYLESHAM, NORFOLK.

N O R W I C H.

At a Court of MAYORALTY, held the Ninth Day of October, 1784.

WHEREAS many ÆROSTATIC MACHINES, afcending by means of Fire attached to them, have been feen in the Night over feveral Parts of this City, and there is Reafon to apprehend that great Mifchief may accrue from the further Ufe of fuch Machines. The Magiftrates of this City hereby declare, that they will profecute, with the utmoft Rigor of the Law, any Per-fon or Perfons that fhall fend up, or caufe to be fent up, any fuch Machine, by which Damage fhall accrue to the Inhabitants of this City.

By the Court, DE HAGUE.

NORWICH, Oct. 6, 1784.

THIS is to give Notice, that the BRIDGE at

Announcement in the *Norwich Mercury* on 16 October 1784, regarding 'aerostatic machines' extracted from newspaper volume. (Courtesy of Norfolk Heritage Centre)

strolls and, as the pleasure gardens closer to the city faded or went downmarket, the ruins at Whitlingham provided a wonderful diversion for such an ambulation. Evidence of later additions suggest that the remains of the church may even have been actively 'beautified' to improve the view.

John Chambers, in his *General History of the County of Norfolk* (1829) noted that

The grounds ... are very picturesque, and invite the pencil of the artist. Rabbits abound here in the extensive woods, the property of Colonel Money ... not far from the church is a small public house, known by the name of Whitlingham White House, a spot remarkable for a singular echo, and much resorted to, by the holiday folks of Norwich, on account of the scenery.

General John Money (1752–1817) was a key ballooning celebrity. He built Crown Point (now Whitlingham Hall) and was one of the first British aeronauts. Major Money, as he was at the time, made his second balloon ascent from Norwich in July 1785, the first having been from London a few days earlier. During Assize Week (of course!) he was to ascend from Quantrell's Gardens: 'From the Disappointment the Public met the last Aerostatic Experiments made here, this Balloon will be kept floating in the air a considerable Time before the Cord will be cut, that the Spectators in the Garden may be perfectly satisfied, and every Person will be admitted near enough the inflating tubes to see the Process of filling'. Admission was to be half a crown and the breakfast and music 5s, with the profit going to the Norfolk and Norwich Hospital, founded only fifteen years earlier.[52]

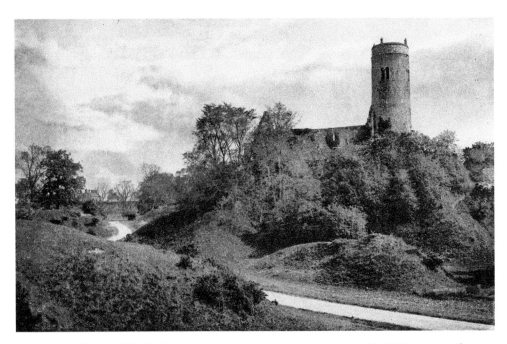

St Andrew's Church, Whitlingham, a nineteenth-century print engraved by T&R Annan, Glasgow. (Courtesy of Picture Norfolk)

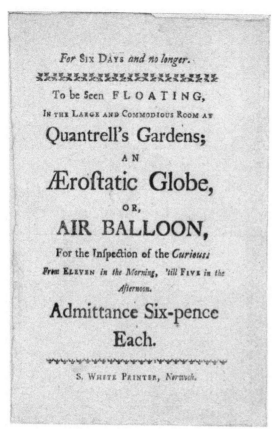

For Six Days *and no longer.*

To be Seen FLOATING,

In the Large and Commodious Room at

Quantrell's Gardens;

A N

Æroftatic Globe,

O R,

AIR BALLOON,

For the Infpection of the *Curious:*

From Eleven *in the Morning,* '*till* Five *in the Afternoon.*

Admittance Six-pence
Each.

S. White Printer, *Norwich.*

A broadside advertising an earlier air-ballooning event at Quantrell's Gardens. (Courtesy of Picture Norfolk)

There were some last-minute difficulties, but Major Money took off as planned before floating over the gardens and across Trowse, Whitlingham and Surlingham. From there, he kept going, and going, all the way to Great Yarmouth and beyond, landing in the sea 'seven leagues off Lowestoft'. According to press reports he was adrift on the waves for five hours before being rescued by boat. By then night had come and he was exhausted. Luckily, Major Money and his rescuers arrived back on shore at Lowestoft at 8 a.m. the next morning, from whence he returned to Crown Point.[53] His courage, composure and intrepidity were complimented in the press, and a twenty-three-page poetical epistle of the feat was written by Marquis Townshend. Two extracts appear below from a copy at Norfolk Heritage Centre, the first describing the crowds at his ascent, the second his rescue:

> What 'squires and farmers flock'd to town!
> And rustics followed from each quarter,
> Ruth miss'd her maid, and Joan her daughter;
> The plow neglected, and the mill,
> No jack wound up, the spit stood still;
> All mutinied, and what should scare 'em?
> E'en justice slept that day at Dereham.

And in the city, not a loom
Was Work'd; cathedral, coffee-room
...
And Haggas caught his sinking friend.
O'er his chill'd limbs they brandy pour,
Chuck'd down a pint, and made for shore...
Than Money felt from Lowestoff strand,
Follow'd by crowds to Poringland [rhyming license!]
There joy grew frantic, shout on shout
Brought all his friends at Norwich out;
With rapture they the man accost,
Whom they had all bewail'd as lost;
Crying dear Money, one and all
No more Balloons, but annual Ball! [Money was famous for his parties][54]

Print showing Major Money in his 'Perilous Situation' ditching in the sea off Great Yarmouth. (Courtesy of Picture Norfolk)

Whitlingham Great Broad.

A plaque commemorating Major Money's flight can be found next to Whitlingham Great Broad (the country park has been created on what was once part of his Crown Point estate, later owned by the Colmans). Much of the land now occupied by the Great and Little Broads was farmland until relatively recently. It was a gravel extraction site managed by Lafarge from 1988, and has since been landscaped and passed to the Whitlingham Charitable Trust on long-term leases. Trowse Wood and Meadow were handed over in 1992, Whitlingham Wood in 1994, Little Broad in 1996 and Great Broad in 2004. Visitors will know that there is more to the site's history than this, though: a ruined manor house remains on the site, as well as the flint barn (now the information centre and café) and remains of chalk workings.

DID YOU KNOW?

William Quantrell wed a pleasure garden singer, Miss Morris, who continued to perform at his gardens after their marriage. Miss Morris is advertised as being from Ranelagh, London, and sung at both Bunn's Gardens and Quantrell's during her career. The couple married in September 1788, shortly after he engaged her to sing with an instrumental accompaniment at Assize Week that year.

Over the decades, the gardens' proprietors were often former innkeepers, and in some ways the gardens were an extension of the public house – entertainment areas, albeit large and outdoors and usually with an admission fee, but where, nevertheless, much of the profit came from the sale of food and liquor. As the nineteenth century progressed, the larger pleasure gardens fell out of fashion. The public wished again for smaller, more intimate spaces, and crowds scattered to newer, simpler tea gardens closer to their new homes – by then springing up all over the expanding city. With the railways came new opportunities to travel further afield – and to the seaside – taking crowds away from their traditional haunts.

Even in 1849 the golden days were being lamented by contemporary writers:

When the charms of music were added to the brilliance of the illuminations – and the entertainments were varied with fine pyrotechnic displays – the Norwich Ranelagh did not fall far short of its metropolitan prototype. The palmy days of these gardens is now fast fading from the recollections of the elders among us; whilst the younger only know of them from what they have heard those elders relate. But there *was* a time, when they were the resort of our fashionable aristocracy; and the public breakfasts ... always given in the assize weeks, were amongst the most gay and pleasant assemblages, that it was ever our good fortune to encounter.[55]

In that same year, the Royal Victoria Gardens was quickly transformed into Victoria Station.

While the larger pleasure gardens have gone, they nevertheless left their mark in the evolution of the city and influenced how the city's residents spent their leisure time. The gardens' history can be placed within a timeline leading, eventually, to public parks like those described in the first chapter of this book, and the myriad of open spaces we enjoy today. I will end this chapter, and this book, with a quote from Elizabeth Girling, the daughter of a Weston Yeoman, who left behind a series of entertaining letters detailing what she got up to as a teenager at the turn of the eighteenth century.[56] This passage describes in a wonderfully warm way her feelings about Assize Week in 1803, and I hope will raise a smile on which to finish.

Here I am just returned from these bustling Assizes to the still more bustling Harvest. The hot meat, hot pudding, and hot weather all together are fit to put anybody into a high fever, especially such as I. The Assize Week I spent at Mr Clipperton's, and a very pleasant one it was, so you may perceive I like a bustle very well ... on Wednesday we were obliged to sleep four in a bed ... We went to the gardens on Friday night; the singing was very moderate, but the fireworks very good.

Endnotes

1. NRO, NCR Case 4a/22/1-18.
2. NC, 26 September 1840.
3. Ketton-Cremer, *Assize Week in Norwich 1688* (1932), p.15.
4. Ibid.
5. NRO, NCR Case 6a/17.
6. NC, 26 September and 10 October 1840.
7. Martin, James, *Report on the State of Nottingham and Other Towns* (1845), p.63.
8. NC, 2 December 1865.
9. NM, 3 November 1866.
10. NM, 21 June 1905.
11. DE, 25 June 1915.
12. DE, 1 October 1915.
13. DE, 19 January 1917.
14. YI, 17 May 1919.
15. www.historypin.org/en/connections-norfolk.
16. Meeres, Frank, *The Story of Norwich* (2011), p.93.
17. NRO, NCR 6a/1.
18. NN, 10 January 1846.
19. NN, 24 October 1846.
20. NN, 29 May 1847.
21. NN, 3 July 1847.
22. White's Directory, 1845.
23. Australian BMD records.
24. Blomefield, *An Essay Towards the Topographical History of Norfolk...* (1806), 4:440.
25. NRO, NCR Case 6a/33.
26. Lee, William, *Report to the General Board of Health* (1851), NHC, N 614, pp.78–81.
27. NC, 11 October 1851.
28. NC, 18 October 1851.
29. NC, 29 April 1854.
30. NC, 17 February 1855.
31. ED, 14 June 2012.
32. Norwich City Council, 2017.
33. B&NP, 17 July 1822.
34. NC, 26 July 1845.
35. NRO, NCC Stockdell 281.
36. Armstrong, Alan (ed. Carole Rawcliffe and Richard Wison), *Norwich Since 1550* (2004), p.245.

37. NRO, MC 24.
38. Steven, George, *Three Centuries of a City Library* (1917), p.5.
39. Nikolaus Pevsner and Bill Wilson, *The Buildings of England, Norfolk I* (1997), p.313.
40. NC, 21 March 1857.
41. NC, 16 September 1854.
42. EEN, 2 August 1898.
43. EEN, 20 August 1898.
44. NC, 5 August 1899.
45. White's Directory, 1845.
46. NC, 3 August 1776.
47. Sir Thomas Browne, published in Sir Thomas Browne's works: including his life and correspondence, 1836. P.45.
48. Ibid, p.281.
49. NHER 26487.
50. NC, 13 JunE 1789.
51. Further reading: Trevor Fawcett, 'The Norwich Pleasure Gardens', in *Norfolk Archaeology* (1972), pp.382–99.
52. NC, 16 July 1785.
53. NC, 30 July 1785.
54. A poetical epistle on Major Money's ascent..., Marquis Townshend, *c.* 1785, Norfolk Heritage Centre, C 821 TOW.
55. NC, 10 November 1849.
56. Paston, George, *Side-lights on the Georgian Period* (1902), p.245.

Acknowledgements

Enormous thanks are due to my husband, for perhaps doing more than his fair share of the chores. Also to my one-year-old son for accompanying me all over historic Norwich (although I hope one day it will inspire in him the same curiosity in history that his mother has).

I could not have illustrated or researched this book without support from Norfolk Library and Information Service (in particular Clare Everitt at Picture Norfolk, Clare Agate, Rachel Willis and Chris Tracy at Norfolk Heritage Centre) and Norfolk Record Office (specific thanks to Claire Bolster, Frank Meeres, Yuki Russell and Gary Tuson). I also need to thank Jonathan Plunkett and Barrett & Coe for their generous permission to use images, David Dobson at NPS Archaeology for agreeing to let me use the churches map, and Dr Joy Hawkins for her advice about theriac.

I hope that you enjoyed the results of my labours.